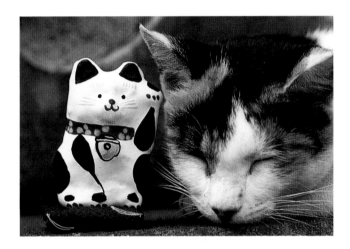

ZEN CATS

ABBEVILLE

PRESS

PUBLISHERS

New York London Paris

ZEN

CATS

Photographs by
YOSHIYUKI YAGINUMA

Text by
JANA MARTIN

Foreword

YOSHIYUKI YAGINUMA

I COULDN'T SAY EXACTLY what made me start taking pictures of cats. But I think it happened as the result of a lot of small things that happened to me, some the traumas of childhood, some the rites of passage as I got older. In college, my friends and I created a set for a poster: we made an oversized egg out of plaster, and put a cat inside it. Then I took a photo of the cat looking out of the egg.

But I've also always been drawn to shrines and temples. Since I was young they've been my favorite place to go. And during a walk among the temples and shrines of Kamakura, about an hour's drive from Tokyo, I came across many cats. They were resting in perfect spots for photographs, so I began to take pictures of them. I couldn't help it. Those cats who lived at the Zuisenji and Jufukuji temples in Kamakura were unforgettable.

I've begun to realize that cats wait for me wherever I go. I felt this very strongly at the ruins of the famous writer Soseki Natsume (his best-known novel, "Wagahai wa Nekodearu" can be translated as "I am a cat"). It was almost evening when I arrived at the ruins, and I was about to leave when I heard a cat meowing.

It sounded like it was talking to me, asking me why it had to wait so long for me to arrive. The cat walked over to me and posed in front of a stone monument. I took a few shots. The cat walked away. Darkness and cold came, and I left. A few days later, I returned to the same spot. But there was no cat.

The same thing happened at the Kita temple in the town of Kawagoe, which is near my home. I went to the temple because I felt as if I were being called by a cat, and one did appear, which I photographed before it decided we were done and walked away. And I can't explain the feeling of being called by a cat in any logical way. It's just a feeling. The same way cats can navigate their way home, perhaps I can navigate my way to a cat.

A dog-lover friend asked me, "Why cats? Why not dogs?" I had no answer. When I'm in a temple photographing cats, I lose track of the passage of time. I'm never bored. But the simple truth is, If you love something, you don't need a reason. You just love it.

On Zen and Cats

JANA MARTIN

CONSIDER THE CAT: self-contained, completely its own creature, staking an indisputable claim to any territory it inhabits, and over any action, or inaction, it takes. Serene. Living in the moment. Existing in harmony with its surroundings—which, in Zen terminology, are qualities of the enlightened.

If so, the cat is the embodiment of Zen. But it's an unwitting embodiment, a natural one. It's an embodiment that doesn't care what we think, yet every time we watch a cat go about its daily life, we can't avoid admiring its absolutely clear existence. To coin the term more casually, it's a Zen kind of embodiment. You don't really have to explain it. As a Zen expression goes, it is.

Cats in Japan have always inhabited a special place in myth, neatly skirting the anthropomorphic symbology of other creatures, yet occupying a certain place. This, too, is a particularly Zen contradiction.

In Japanese mythology, Buddhist or Shinto, certain animals have been given remarkable powers and associations. A centipede is the embodiment of a vicious monster; a lowly toad accompanies

7

the Japanese sage Gama-Sennin, who can assume the shape of a snake. Inari, the god/goddess of rice, can take the shape of a fox, and when foxes are seen coming down a mountainside during harvest time, this is considered a good omen for the rice crop.

Whether or not the real reason for foxes during harvest has to do with the proliferation of rodents looking for food has little to do with it. But nature's side in this relationship still isn't to be overlooked, since the interaction of the natural world and the un-explainable factor into any myth. In Japan, there are gods of water, of mist, of trees, of flowers, of rocks. Kirin, the Japanese unicorn, punishes the wicked with a stab of its horn and acts as granter of luck and protector to the just. But the cat?

Two common embodiments of the cat in Japanese mythology are at two extremes. There is the cat god of lightning, a frenzied creature called Raiju, who leaps frantically from tree to tree in a thunderstorm, scratching the trees with its razor-sharp claws and creating the sound of thunder. Then, there is the cat god of good luck—Maneki Neko, who sits beneficently with its paw raised, and has become absolutely ubiquitous in countless shops and homes. In the complex history of this myth, the gesture of the raised paw may be based on images of cats washing their face—an action they sometimes perform in the company of strangers. At some point, a link was made between a cat washing its face and the presence of visitors; as time went on, it became causal—the sight of a cat wash-ing its face could actually mean visitors were coming. From there came the next step: that a cat washing its face would invite visitors, much like an inviting hand.

If Maneki Neko's left paw is raised, the cat is inviting visi-tors—or in the shopkeeper's viewpoint, customers. But if the right paw is raised, the cat is inviting luck and good fortune, in the form

of money. And to keep up with the times, Maneki Neko statues imported to the United States gestures with the back of the paw, as an American's beckoning gesture shows the back of the hand.

Coloration matters as well: a tri-colored Maneki Neko means especially good luck; a black one will ward away evil intentions, popular among women worried about stalkers. But with all the details, Maneki Neko is still different than other symbols, as is Raiju. For in both, the essence of the animal, or the essential elusiveness, permeates the myth. Both differ from the metaphysical high concept of mist as a ghost, or snow as a phantom. For in both, the cat is simply a cat. Rather than taking an element and adding a physical being, the myth takes the physical and adds the element. This is a great distinguisher. A cat does not flash as if it were lightning. Lightning scratches—as if it were a cat.

Among Yaginuma's photographs are two taken at the Komyo-ji Temple in Kamakura in the Kanagawa prefecture. In one (page 26), a calico cat sleeps nestled against a tiny, spotted Maneki Neko, whose customary painted golden bell attached to its customary red collar is about the same size as the real cat's nose. In another (page 91), a calico cat sleeps on the lap of a seated Buddha, or Bosatsu. The statue wears an apron around its neck.

If you look at the development of Japanese mythology, these two elements—the cat statue's collar and the Buddha statue's apron, are most likely related. The collar evolved from a red apron affluent ladies of the Edo period (1603–1868) put on their beloved felines (with a bell attached). During that time, it was also customary to place an apron around the neck of a Ji-zou, a Buddha statue placed alongside the road. The apron symbolized the wish for a child to grow peacefully. All over Japan, there are still Buddhas by the road with aprons tied around their necks, blowing in the winter winds,

the summer breezes. And all over Japan are Maneki Neko, practically smiling, a red apron tied around their neck.

Why has Yaginuma traveled throughout Japan, frequenting its famous temples and shrines and photographing the cats who live there? Because the cats call him, as he puts it. They are as much a part of the landscape as the statues and architecture, yet they also add an element of life. Whether at the Kita temple of Kawagoe, or the famous grave of Soseki Natsume, one of Japan's most beloved writers, the cats are always waiting for Yaginuma and his camera.

The great Zen master Basho (1644–1694), who walked the old roads of Japan in search of his own enlightenment, often wrote in his haiku of a kind of walking solitude. He expressed a solitude in motion, but not in desperation, a slightly wistful solitude—in its certainty, perhaps, but also a self-confident one. His reflection on the act of walking alone is perhaps like a prism, producing a hundred facets, all of which glint—if you look for long enough—in his poem:

On this road
No one will follow me
In the Autumn evening.

That's how we look at cats, as one facet. They're solitary. Alone. Unfollowed. Night walkers. But how does a cat see it? With that same self-assured acceptance, knowing no one will follow me? If half the work of a student of Zen is learning how not to need others, how to be alone and peaceful in that state, we have a lot of learn from cats.

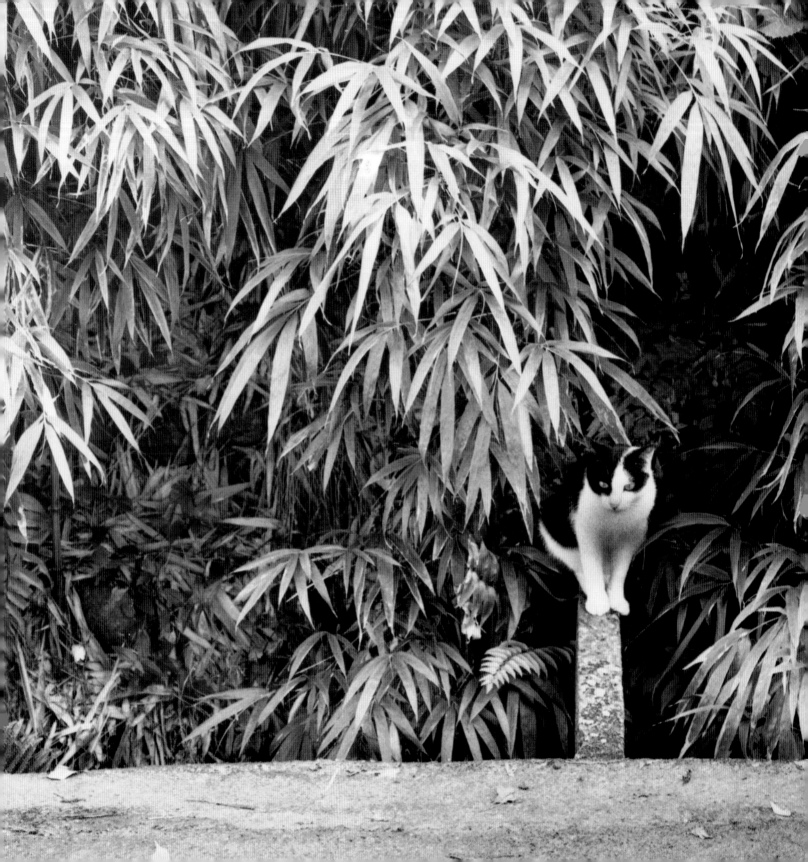

Goodbye. I will go
alone down Kiso Road
old as autumn

BUSON

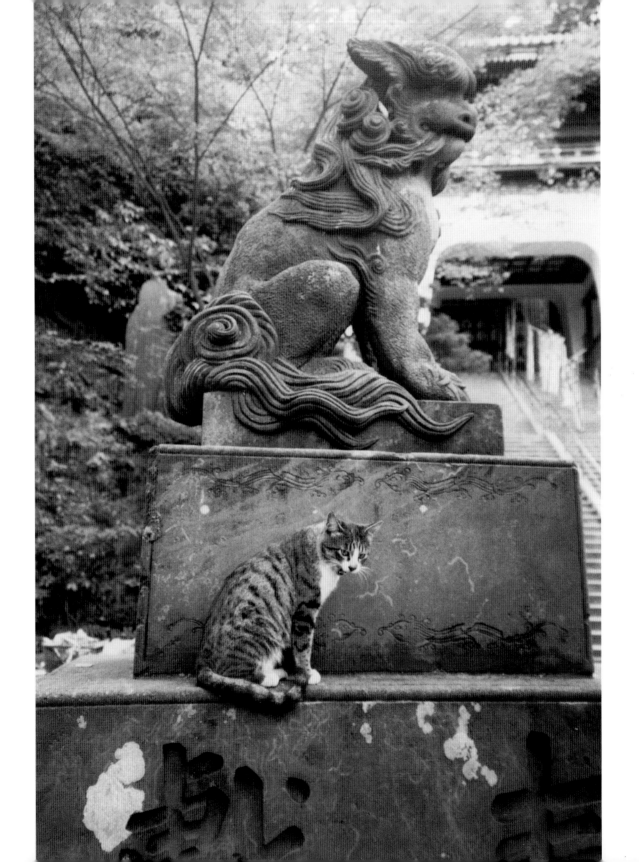

If the traveler can find

A virtuous and wise companion

Let him go with him joyfully

And overcome the dangers of the way

BUDDHIST PROVERB,
FROM *The Dhammapada:
The Sayings of the Buddha*

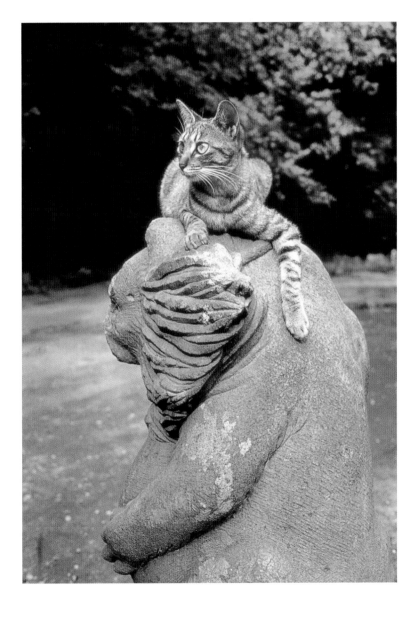

OPPOSITE: Enoshima,
Kanagawa Prefecture
RIGHT: Tetsugakudo Park,
Nakano Ward, Tokyo

As certain as color

Passes from the petal,

Irrevocable as flesh,

The gazing eye falls through the world.

ONO NO KOMACHI

Sankeien Garden, Yokohama,
Kanagawa Prefecture

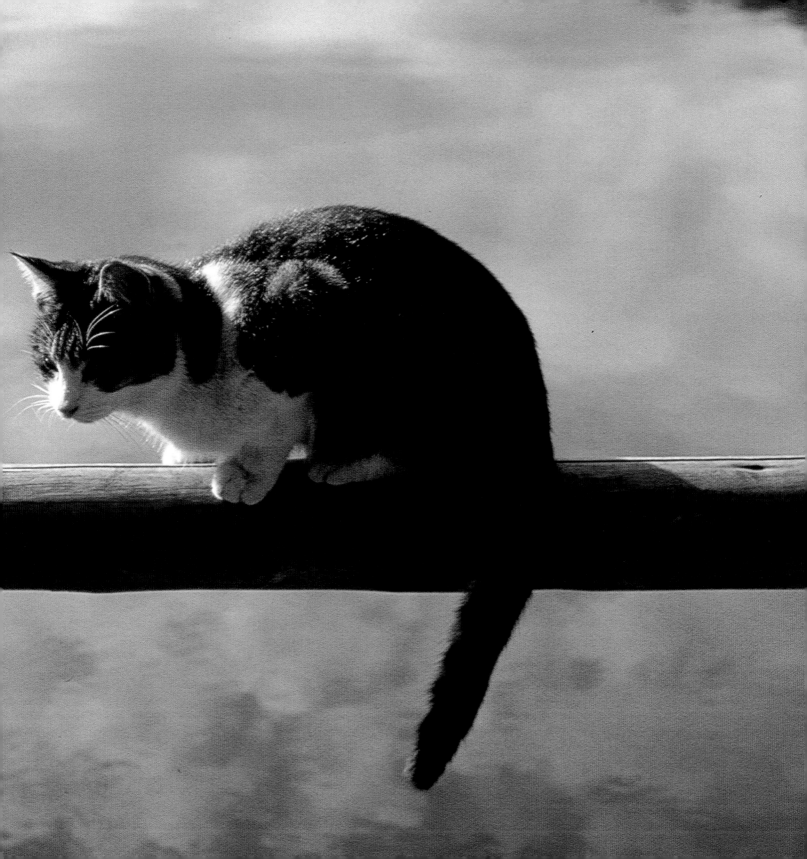

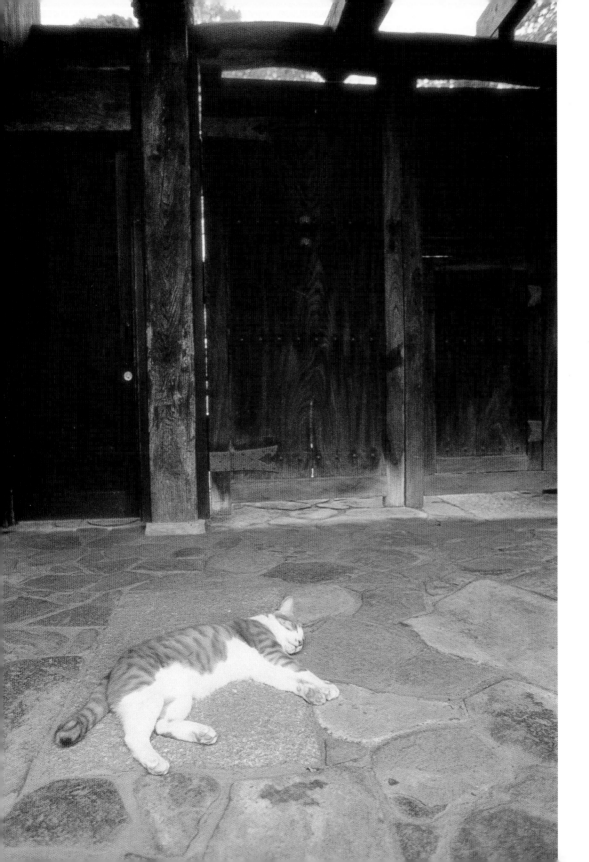

LEFT: Yamanouchi, Kamakura,
Kanagawa Prefecture
OPPOSITE: Yanaka Reien
Cemetery, Yanaka,
Taito Ward, Tokyo

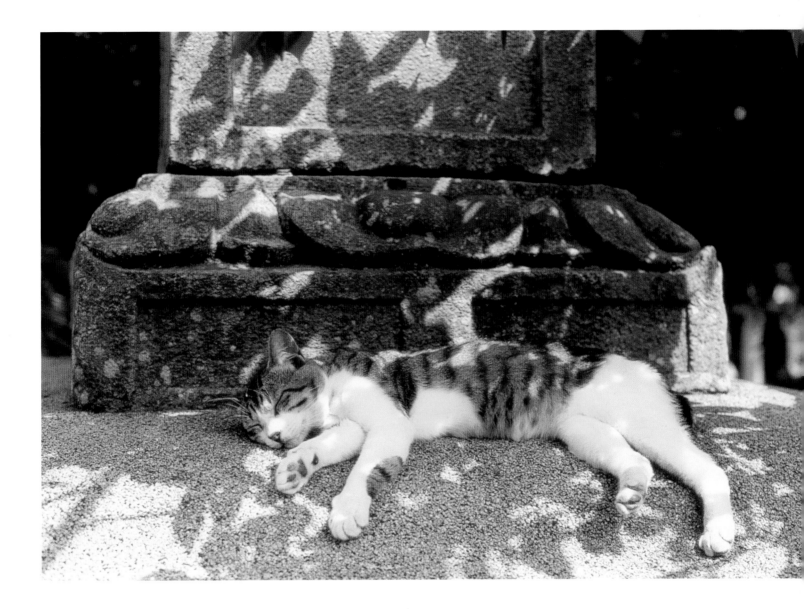

King Tiger, surfeited, just sleeps and snores,

But helter-skelter run his hungry deer.

Hai Au Tu, *Zoo Cages* 19

Since I got my cat Five White

the rats never bother my books.

This morning Five White died.

I make offerings of rice and fish,

bury you in mid-river

with incantations—I wouldn't slight you.

Once you caught a rat, ran round the garden with it

 squeaking in your mouth;

you hoped to put a scare into the other rats,

to clean up my house.

When we'd come aboard the boat

you shared our cabin

and though we'd nothing but meager dried rations,

we ate them without fear of rat piss and gnawing—

because you were diligent,

a good deal more so than the pigs and the chickens.

People make much of their prancing steeds;

They tell me nothing can compare to a horse or donkey—

Enough!—I'll argue the point no longer,

Only cry for you a little.

 MEI YAO-CH'EN, *An Offering for the Cat*

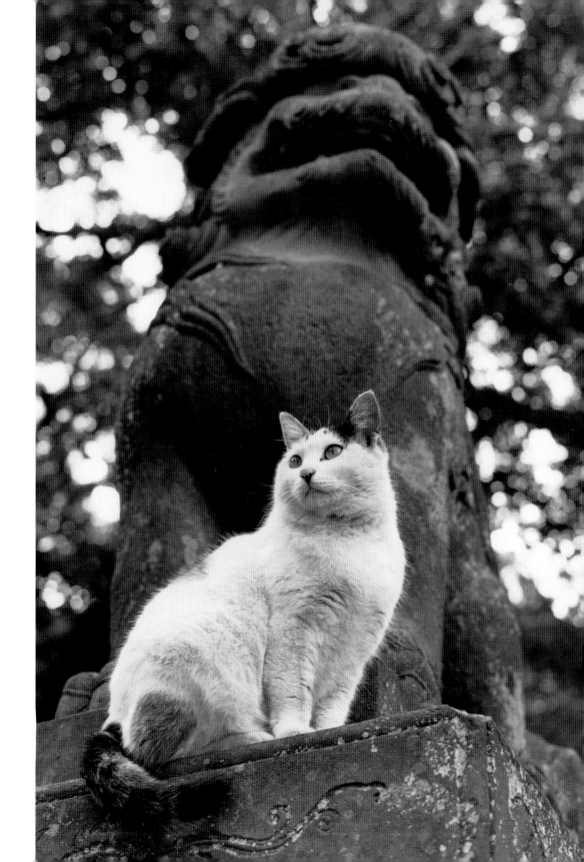

Enoshima,
Kanagawa Prefecture

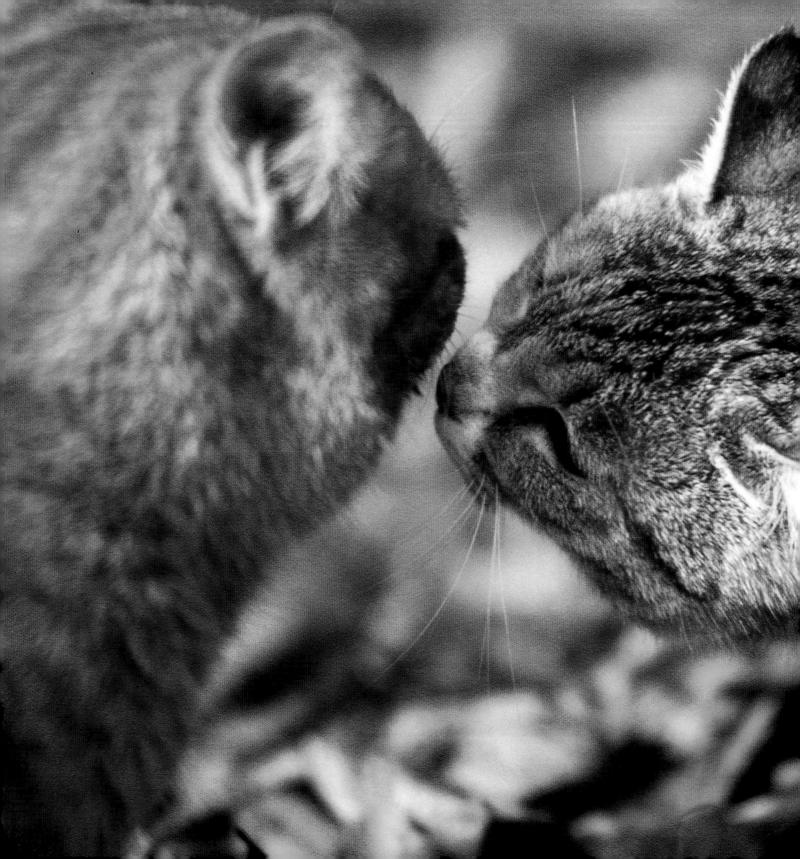

Head pillowed on arm,
such affection for myself!
And this smoky moon

BUSON

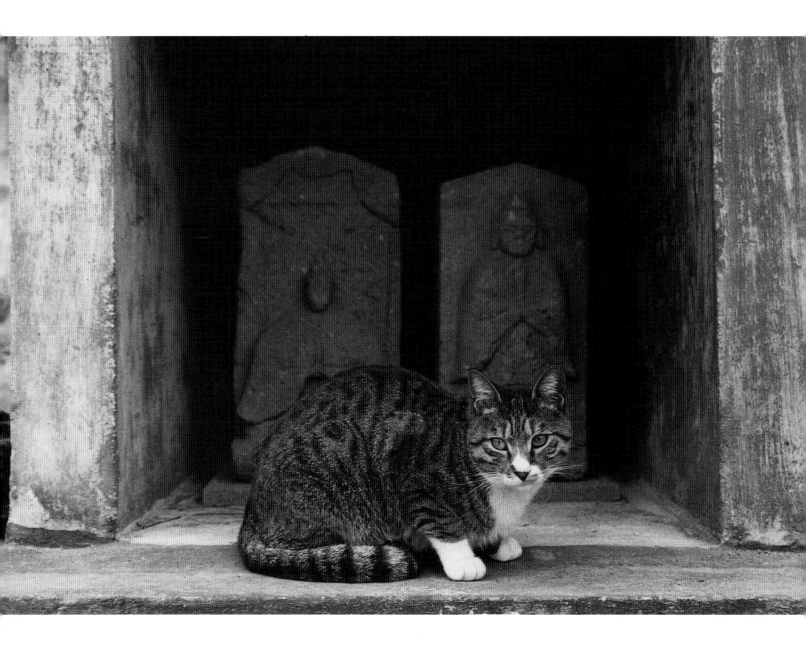

ABOVE: Enoshima,
Kanagawa Prefecture
OPPOSITE: Komyo-ji
Temple, Kamakura,
Kanagawa Prefecture

Tell me, did I stop here once during a previous

 existence?

I find myself looking for my footprints

left during one cycle of birth and death.

 THICH NHAT HANH, *Voyage*

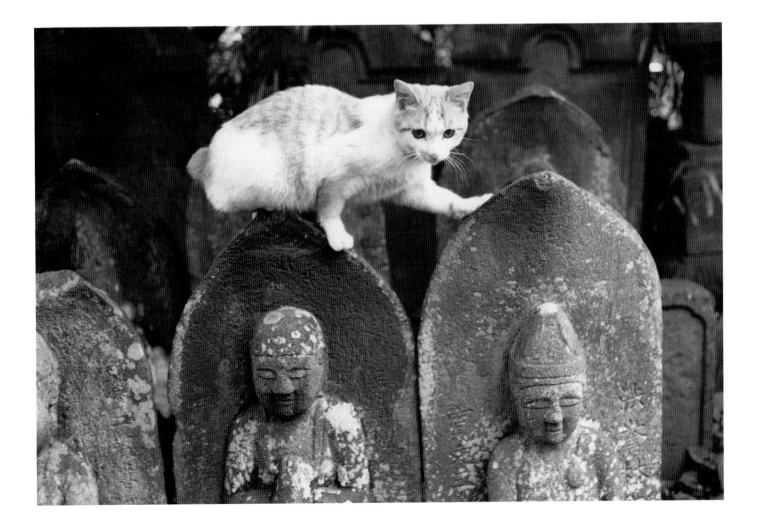

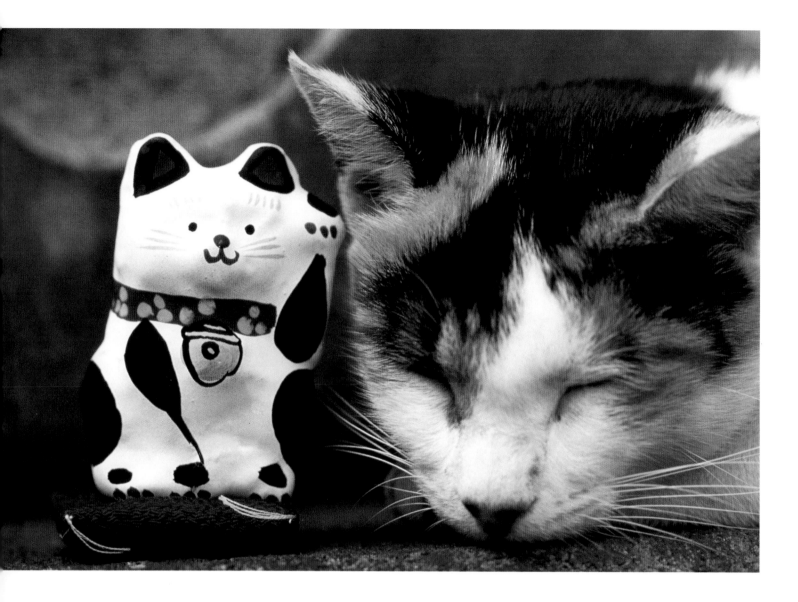

ABOVE: Ikegami Honmon-ji Temple,
Ota Ward, Tokyo
OPPOSITE: Komyo-ji Temple,
Kamakura, Kanagawa Prefecture

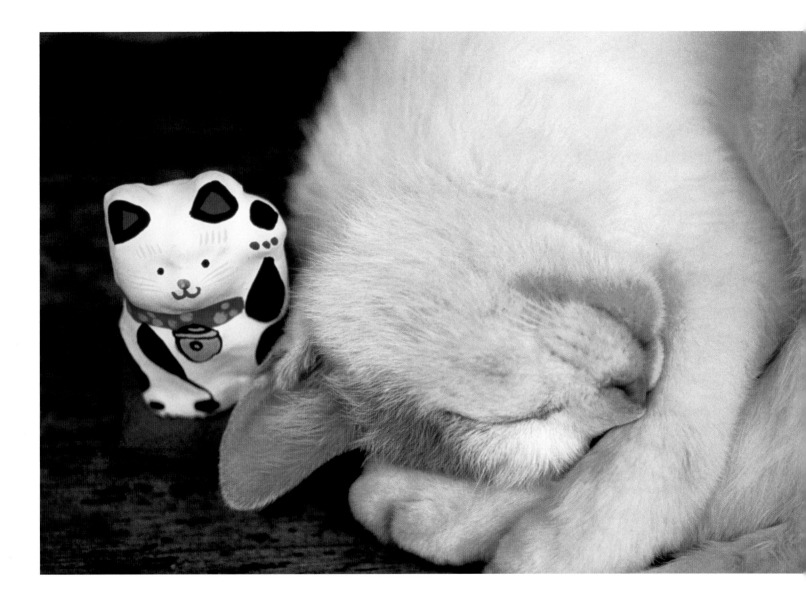

Around my pillow in my dreams

The perfume of orange blossoms floated

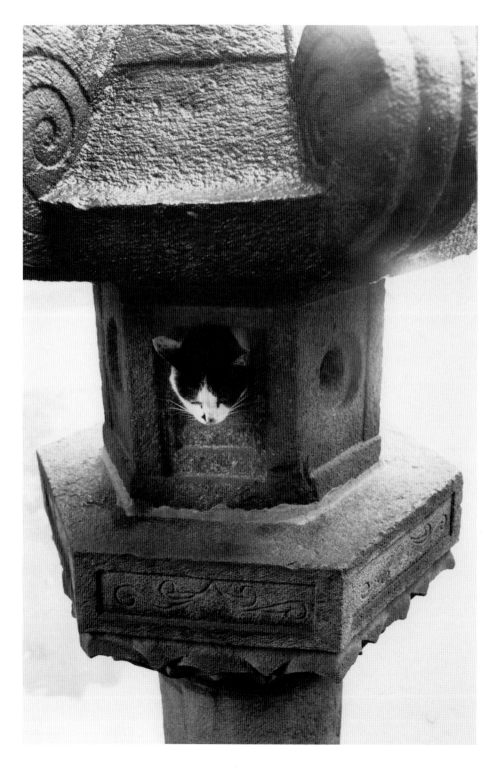

The frost lies white
On the suspended
Magpies' Bridge.
The night is far gone.

YAKAMOCHI

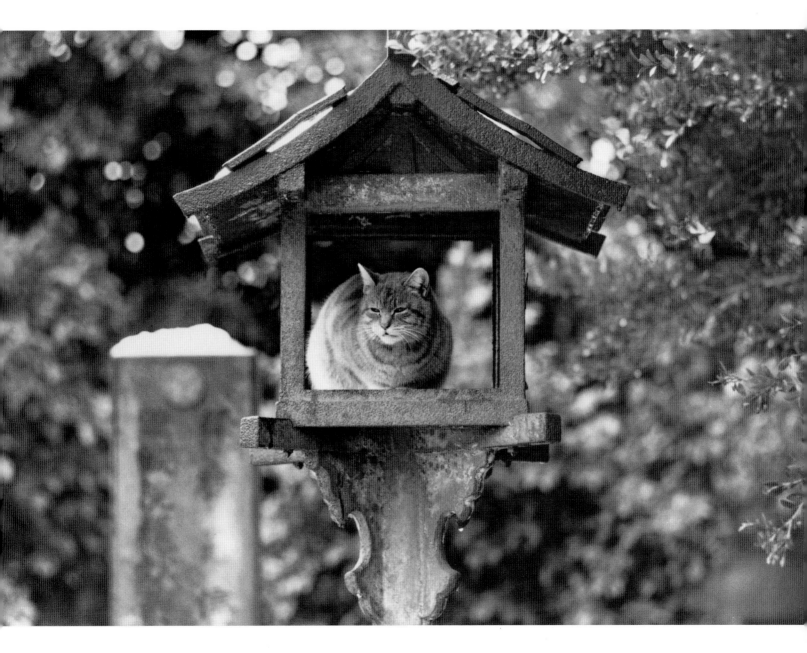

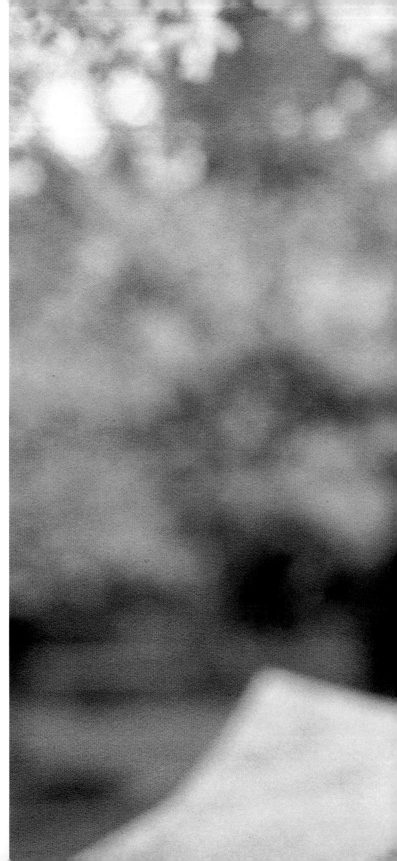

... I float and drift, now near,

 now far—

Jade sings ten thousand melodies,

 unheard.

In silence, pearls drop one

 by one

In a clear lake, pristine beside the steps.

THE LU, *Opium*

Komyo-ji Temple,
Kamakura,
Kanagawa Prefecture

30

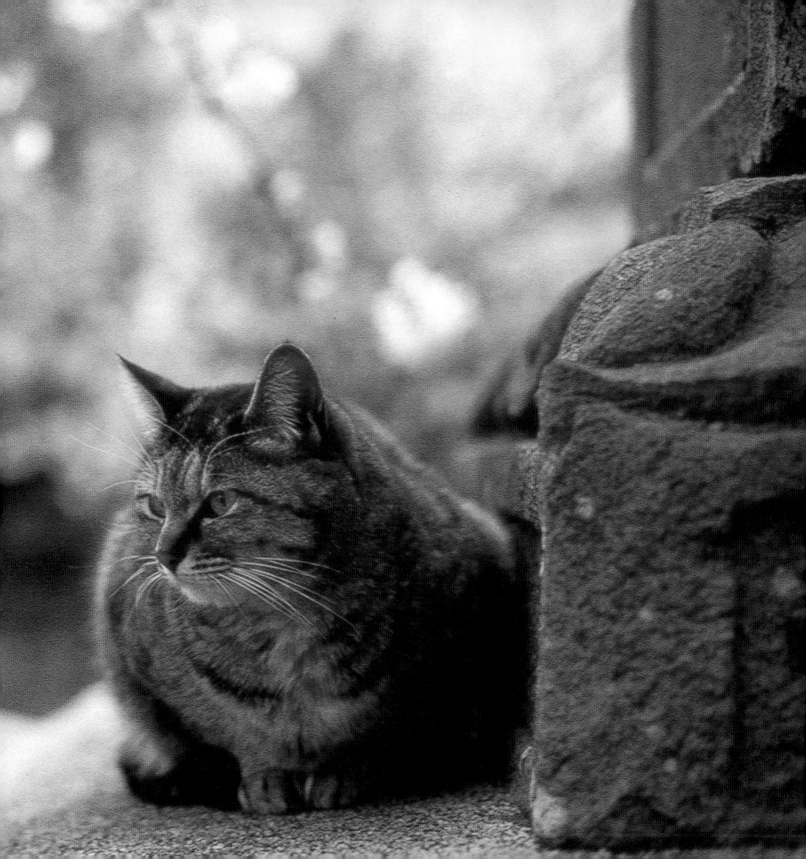

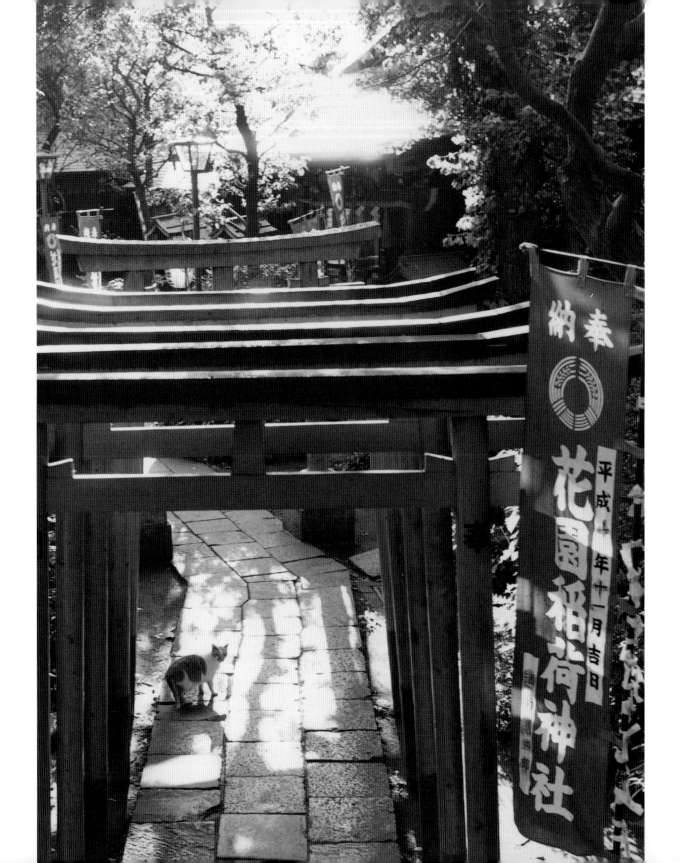

OPPOSITE: Hanazono Inari Shrine,
Ueno, Taito Ward, Tokyo
RIGHT: Sankeien Garden,
Yokohama, Kanagawa Prefecture

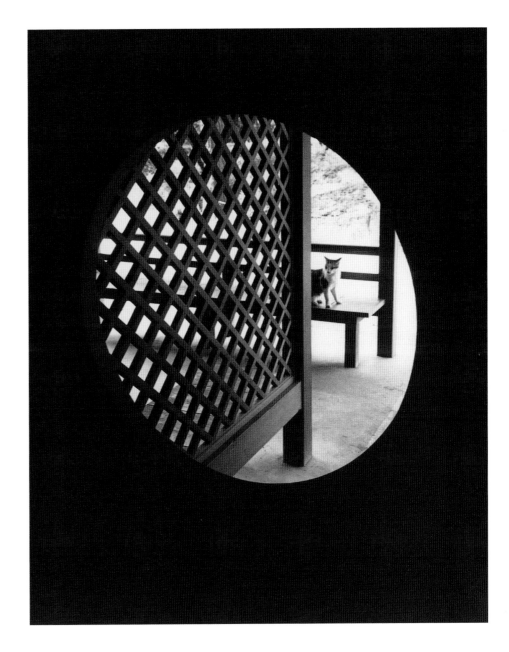

Out of the darkness

on a dark path,

I now set out.

Shine on me,

moon of the mountain edge.

IZUMI SHIKIBU

The leaves of the bush clover rustle
 in the wind.
I, not a leaf,
Watched you without a sound.
You may have thought I paid no
 attention.

KENREI MON-IN UKYO NO DAIBU

Komyo-ji Temple, Kamakura,
Kanagawa Prefecture

34

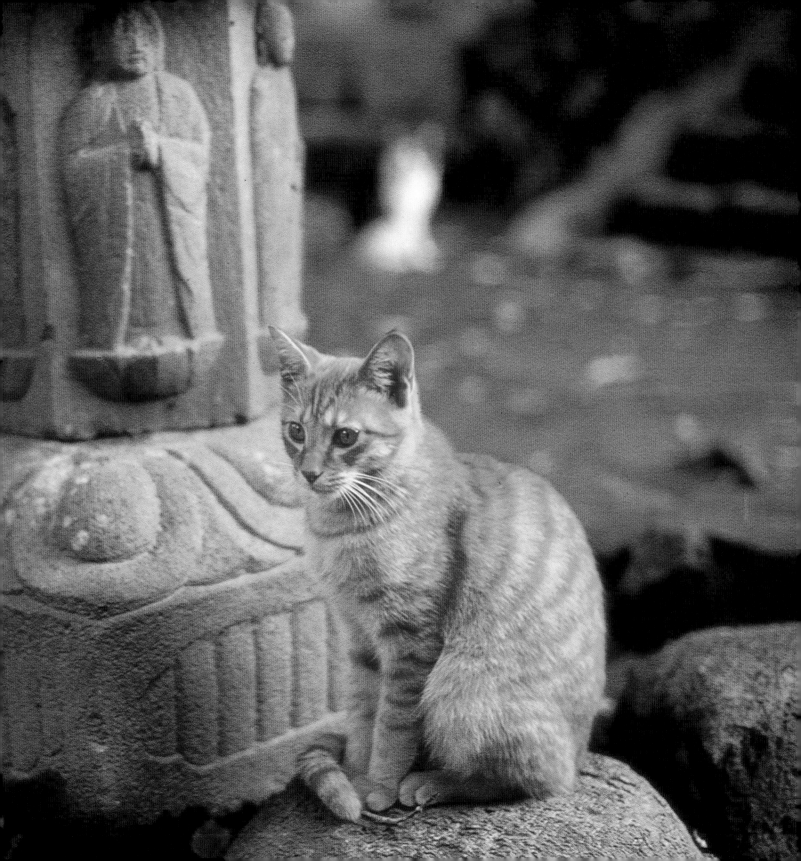

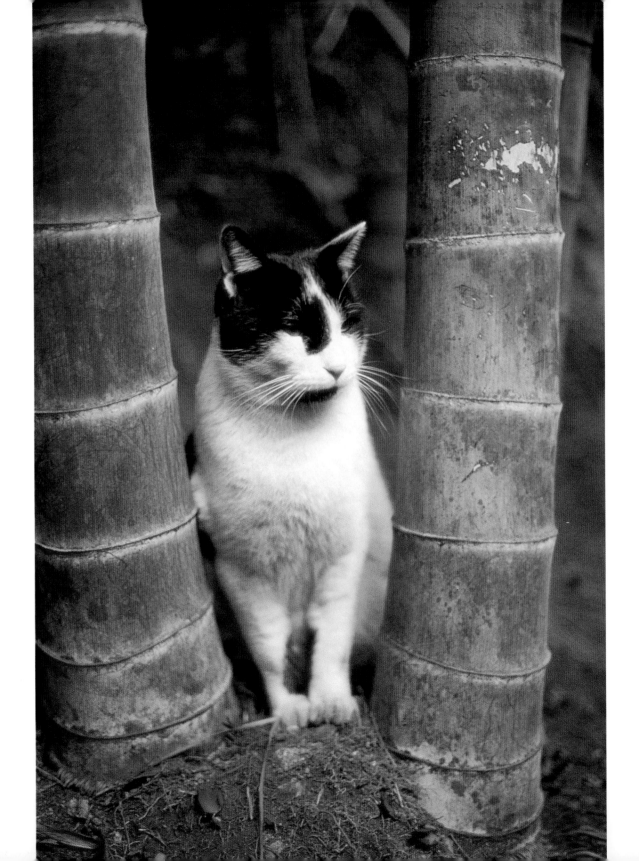

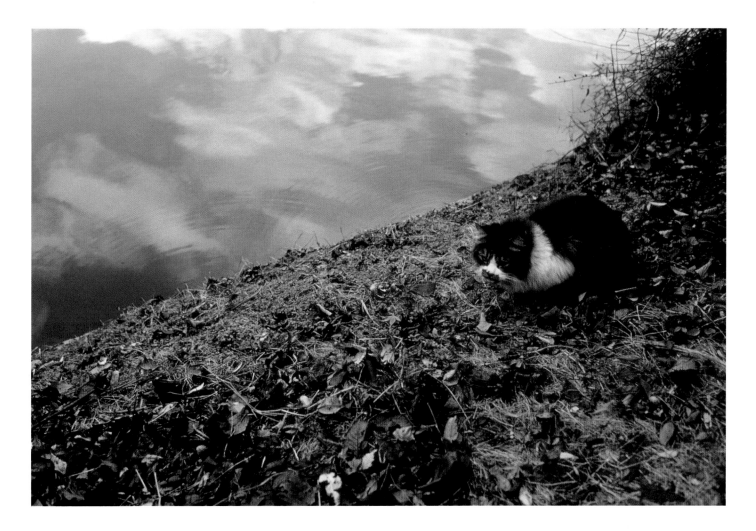

This bright harvest moon
keeps me walking all night long
around the little pond

BASHO

OPPOSITE: Senso-ji Temple,
Asakusa, Taito Ward, Tokyo
ABOVE: Shinjuku Gyoen Park,
Shinjuku Ward, Tokyo

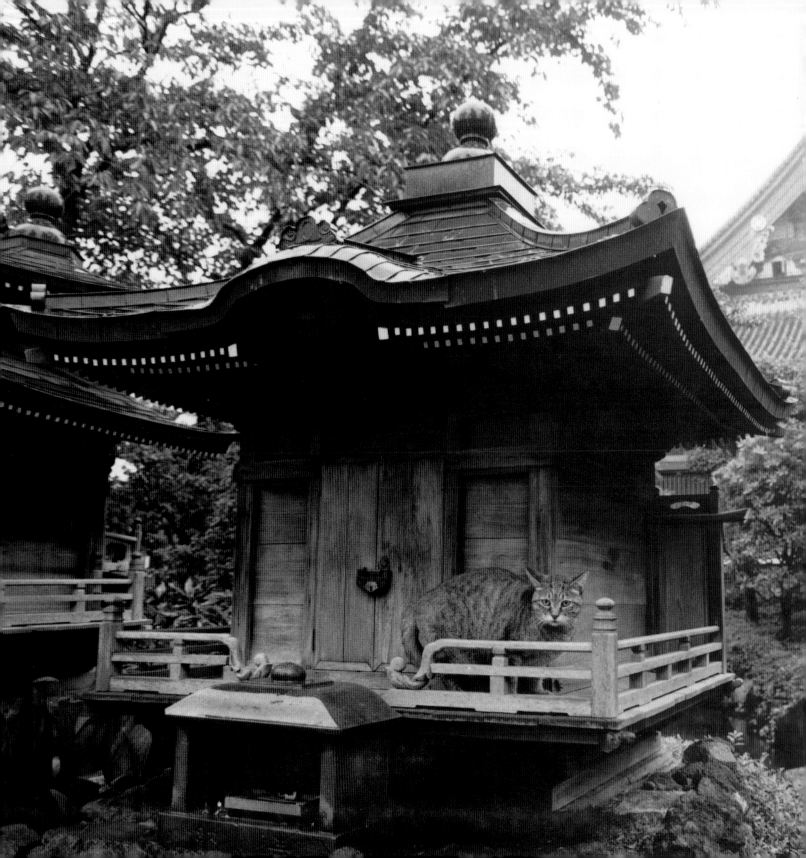

This grasped, all's dust—
The sermon for today.
Lands, seas. Awakened,
You walk the earth alone.

SEIGENSAI

Senso-ji Temple, Asakusa,
Taito Ward, Tokyo

39

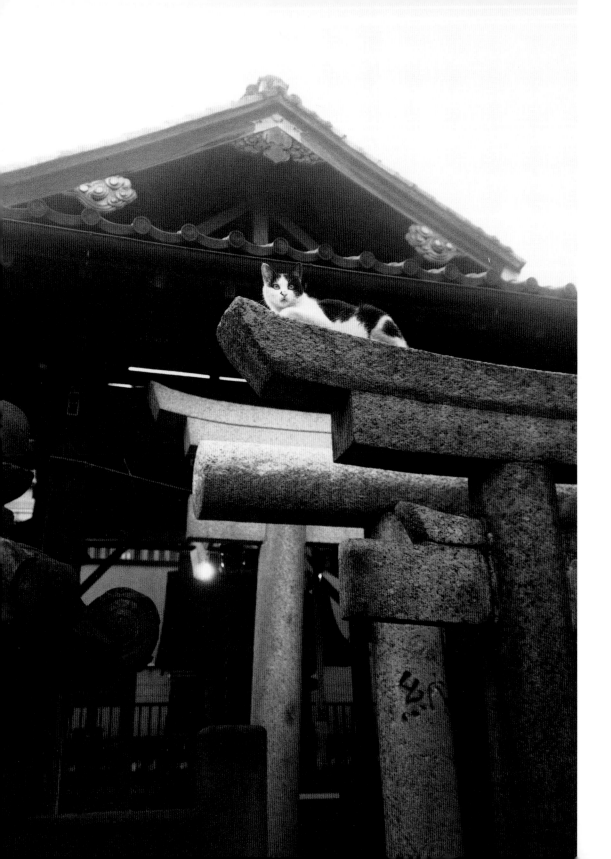

LEFT: Senso-ji
Temple, Asakusa,
Taito Ward, Tokyo
OPPOSITE: Hanazono
Inari Shrine, Ueno,
Taito Ward, Tokyo

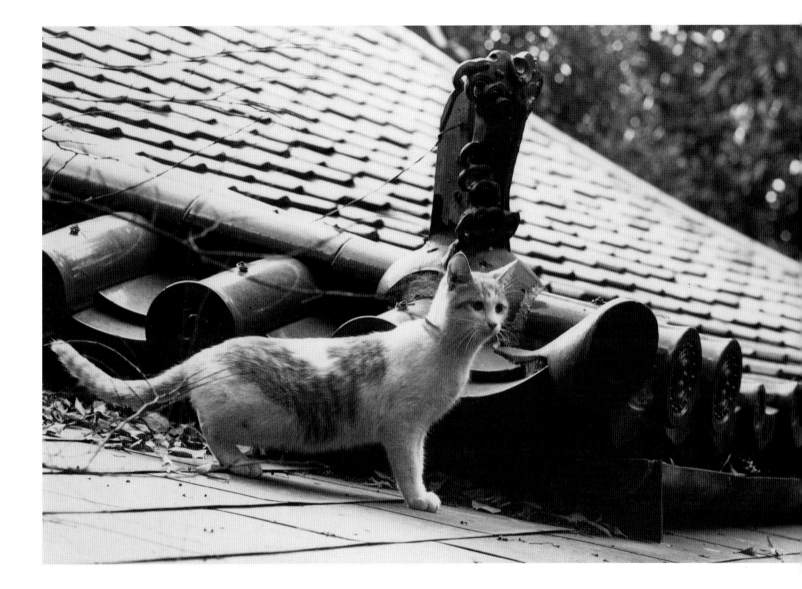

Kannon's tiled temple

roof floats away far away in clouds

of cherry blossoms

BASHO

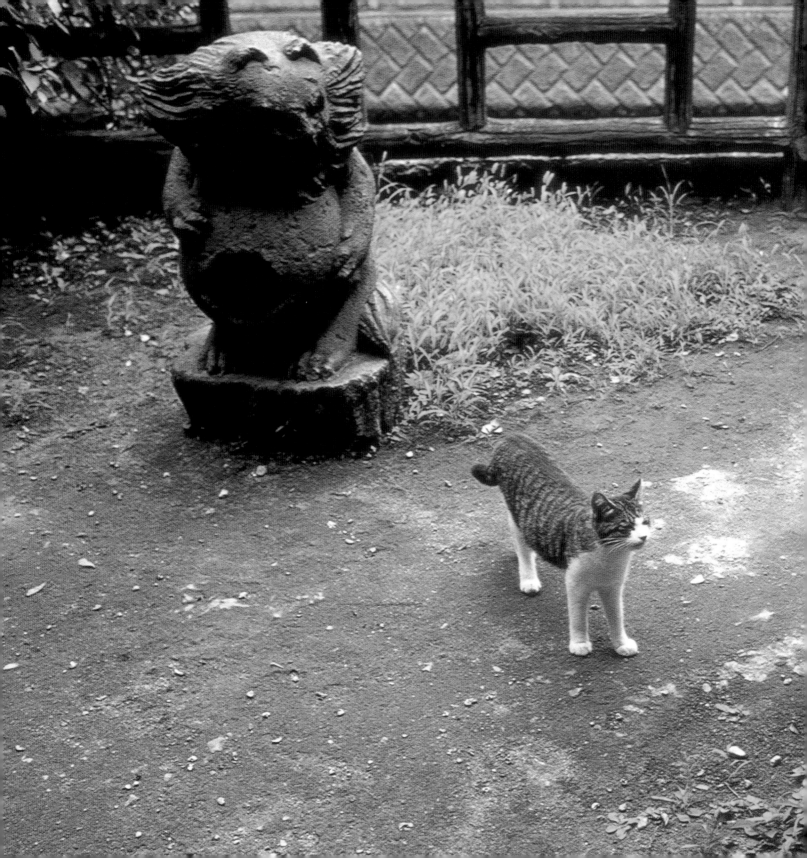

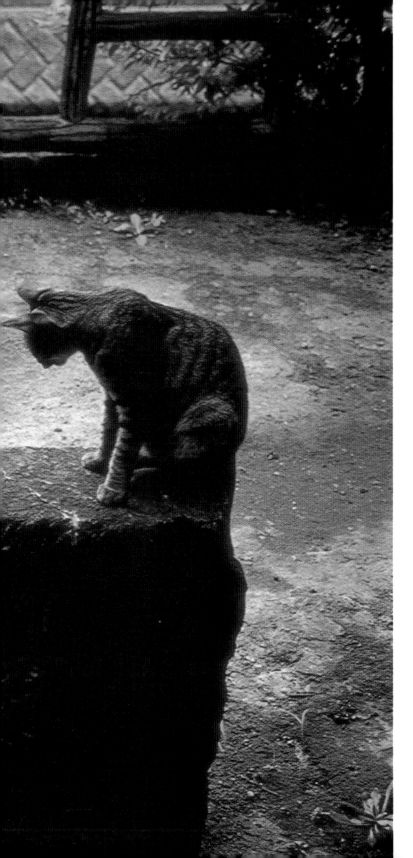

Sometimes I come across

an old man of the woods

we talk and laugh

and forget to go home

<div align="right">

WANG WEI, FROM
My Mount Chungnan Cottage

</div>

Tetsugakudo Park, Nakano
Ward, Tokyo

BELOW: Tamachi,
Minato Ward, Tokyo
OPPOSITE: Komyo-ji
Temple, Kamakura,
Kanagawa Prefecture

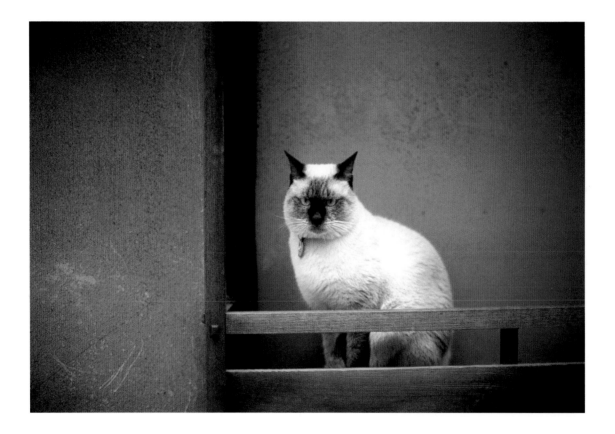

In the eyes of the cat

Is the color of the sea,

On a sunny day, in winter.

YORIE, *The Cat's Eye*

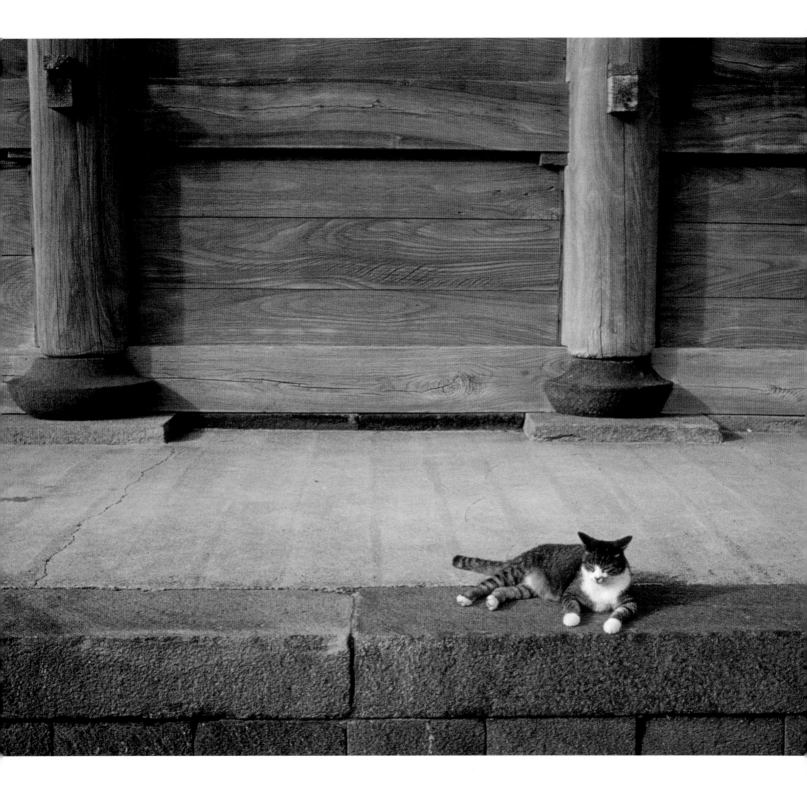

With one foot on the brick step,

The All burst in my head.

I had a good laugh by

The box tree, moon in the bluest sky

<div style="text-align: right">CHORO</div>

Yanaka Reien Cemetery,
Yanaka, Taito Ward, Tokyo

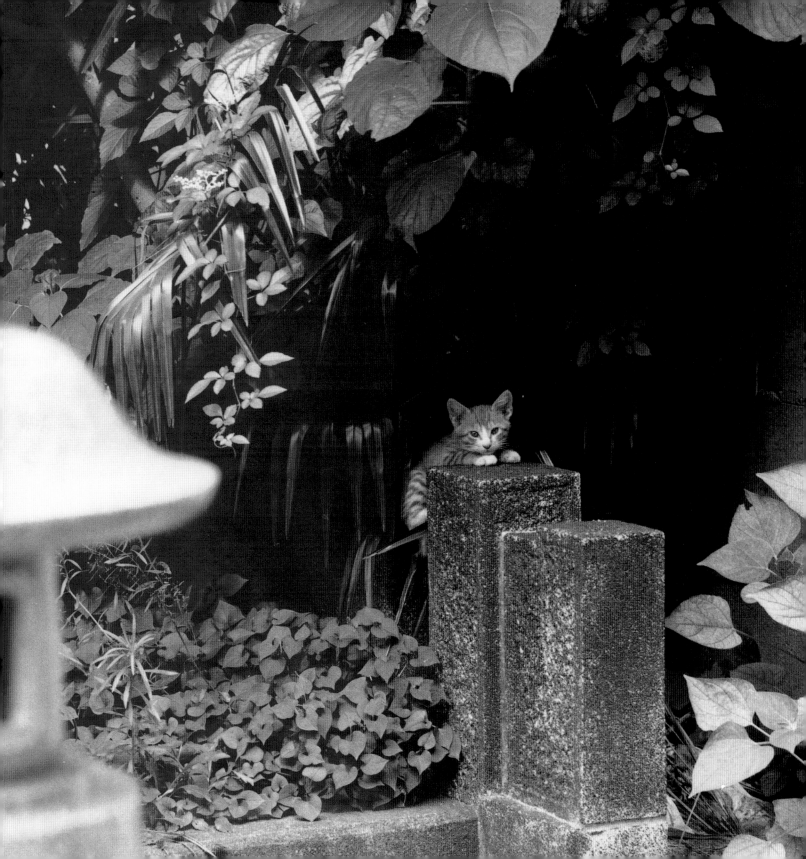

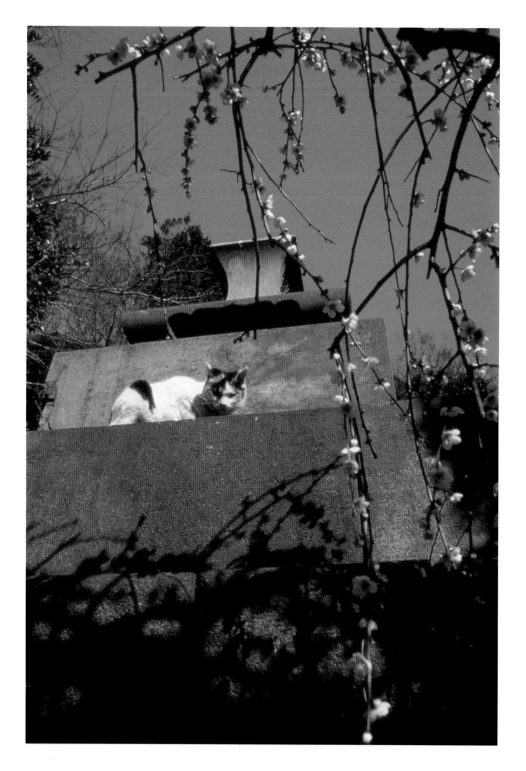

So very still, even

cherry blossoms are not

stirred

by the temple bell

FUHAKU

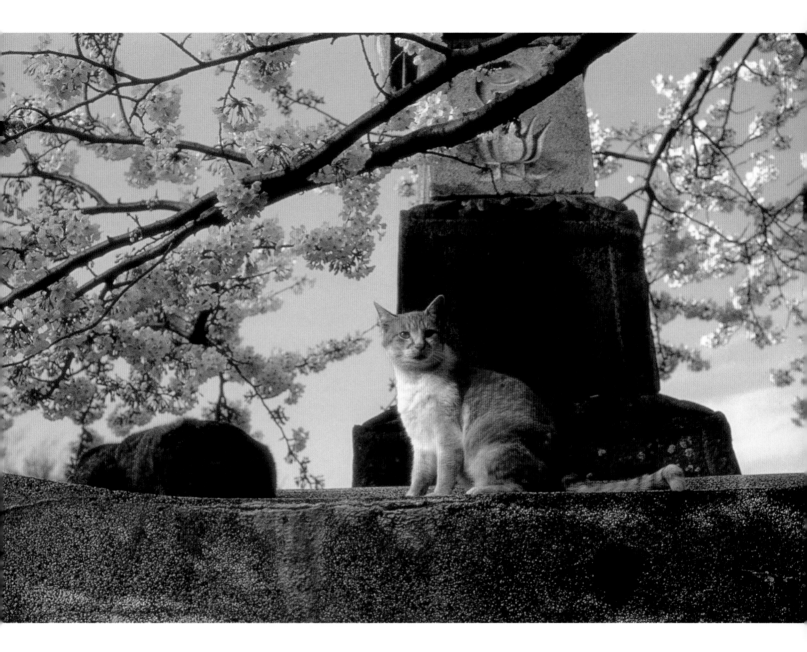

OPPOSITE: Ikegami Honmon-ji
Temple, Ota Ward, Tokyo
ABOVE: Komyo-ji Temple,
Kamakura, Kanagawa Prefecture

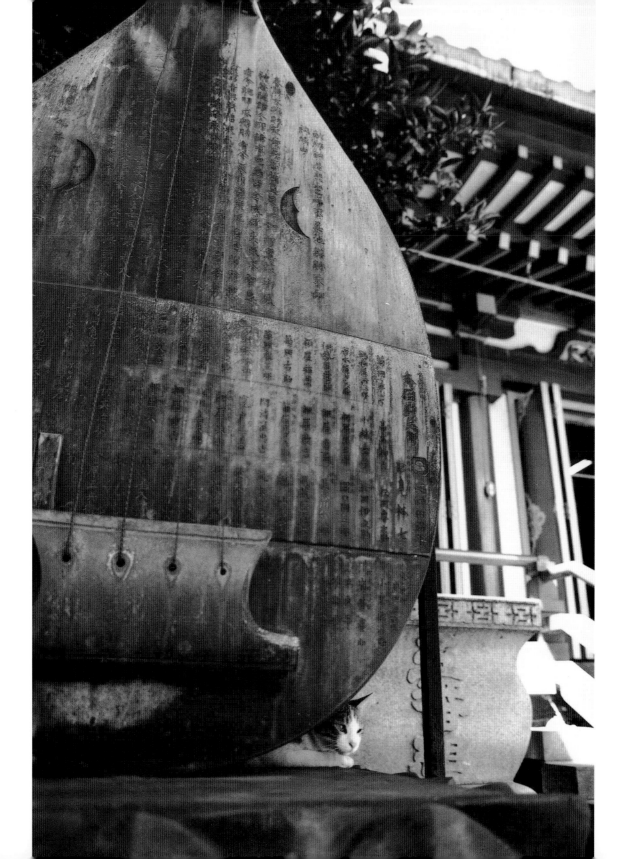

Deep here in the palace
 I gaze at the bright moon—
east, west, four, five hundred times
 I've watched it grow round!

 Po Chü-I, from *White-Haired*
 in the Shang-yang Palace—
 Pitying the Unloved

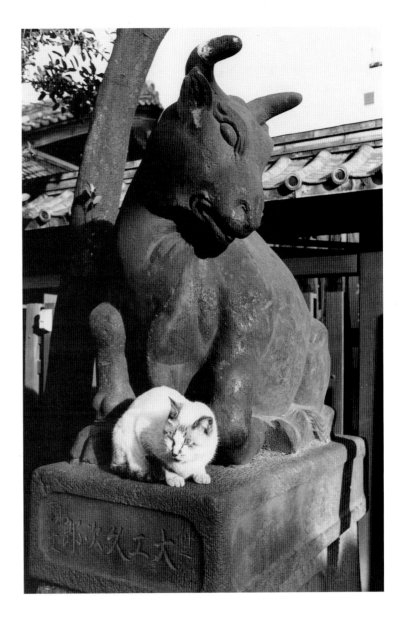

opposite: Benten-do, Shinobazu-no-ike, (pond), Ueno, Taito Ward, Tokyo
right: Ushijima Shrine, Mukojima, Sumida Ward, Tokyo

51

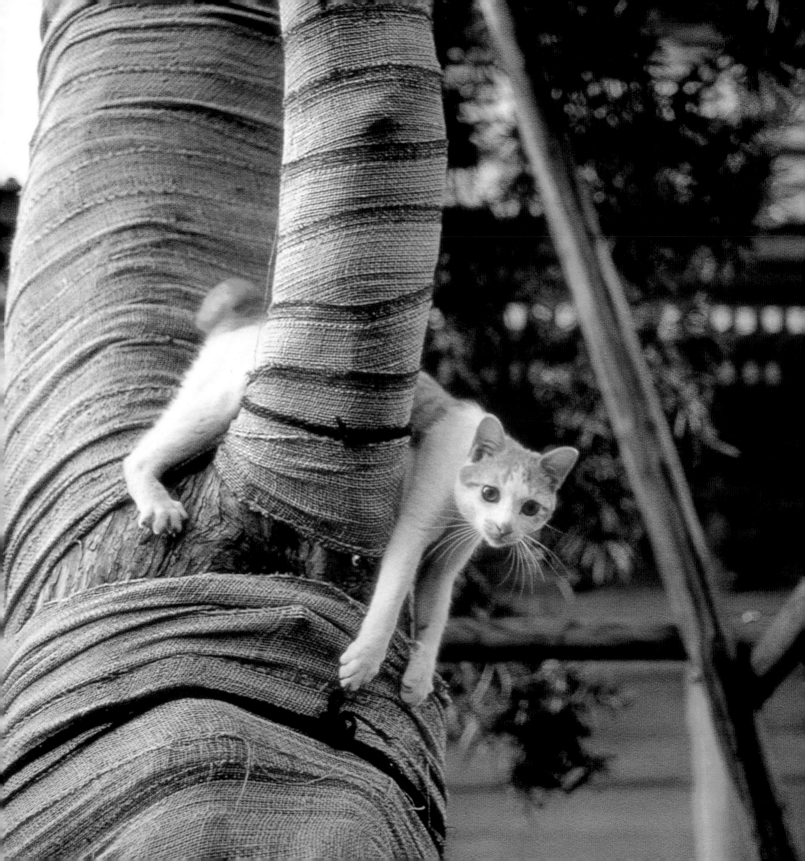

Deep eyes light up to see the universe,
and vibrant ears catch music from the
 spheres.
The silk of hair smells fragrant with
 all scents,
and to a perfect rhythm throbs the
 chest.

HUY CAN, *The Body*

Komyo-ji Temple, Kamakura,
Kanagawa Prefecture

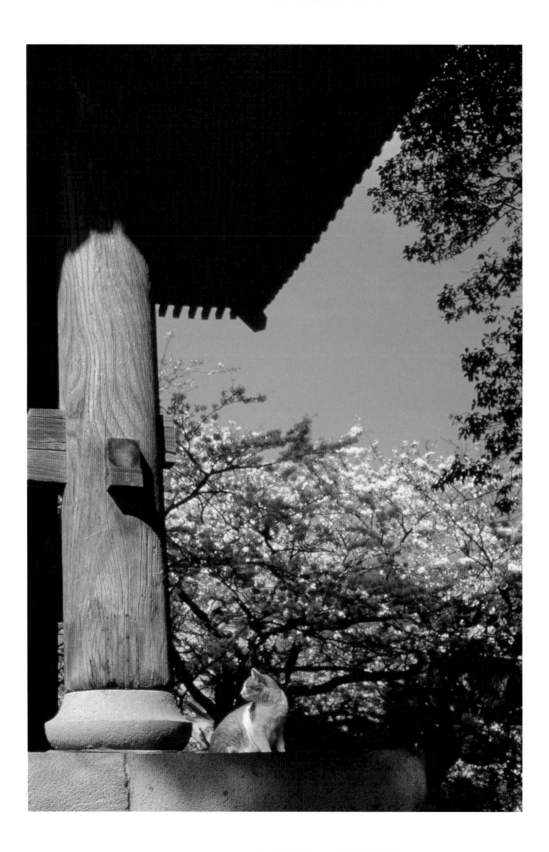

The colors of the flower fade

as the long rains fall,

as lost in thought,

I grow older.

ONO NO KOMACHI

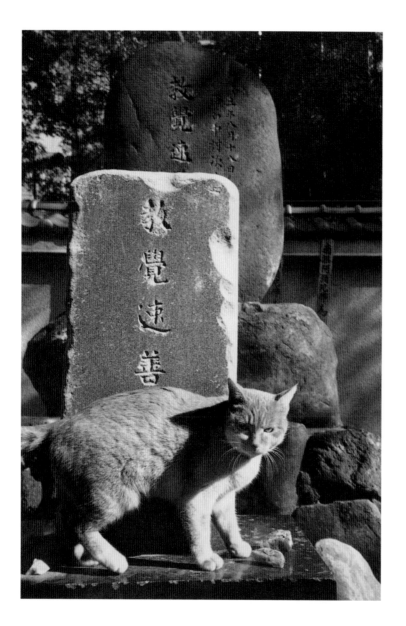

I turn my head, ask this pair of stones
if they'd consent to keep an old man
company.
And though the stones are powerless
to speak,
They agree that we three should be
friends

PO CHÜ-I, *A Pair of Stones*

Others may forget you,

but not I.

I am haunted by your

beautiful ghost.

YAMATOHIME

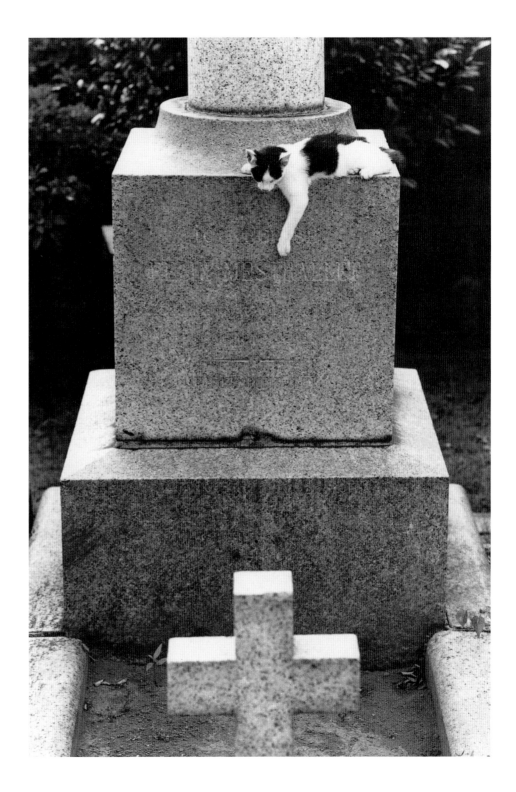

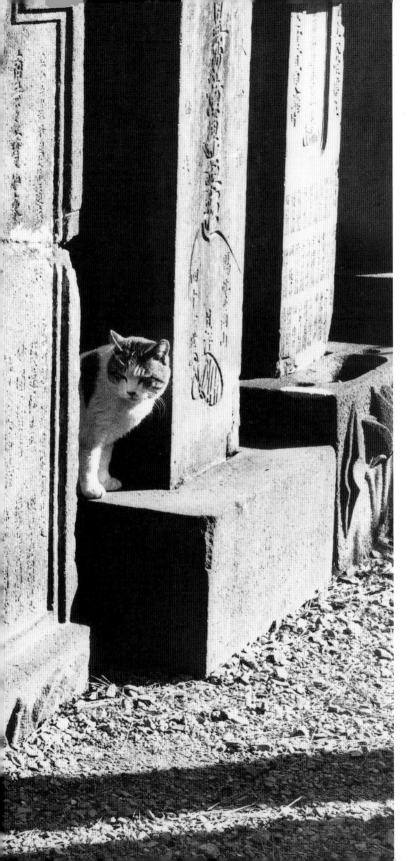

The stars, about to fade, are straggling
 east—
A distant bell now tolls the night's
 last watch.
In peace the primal motive prompts
 the world—
Across the rivers speaks a lonely voice.
Unsettled herons cry in wind-girt
 groves;
Awakened ravens caw on moonlit trees.
In every household, folks have stirred
 from bed—
The cock, proclaiming daybreak, crows
 and crows.

MAC THIEN TICH, *The Morning Bell
at Tieu Monastery*

Ikegami Honmon-ji Temple,
Ota Ward, Tokyo

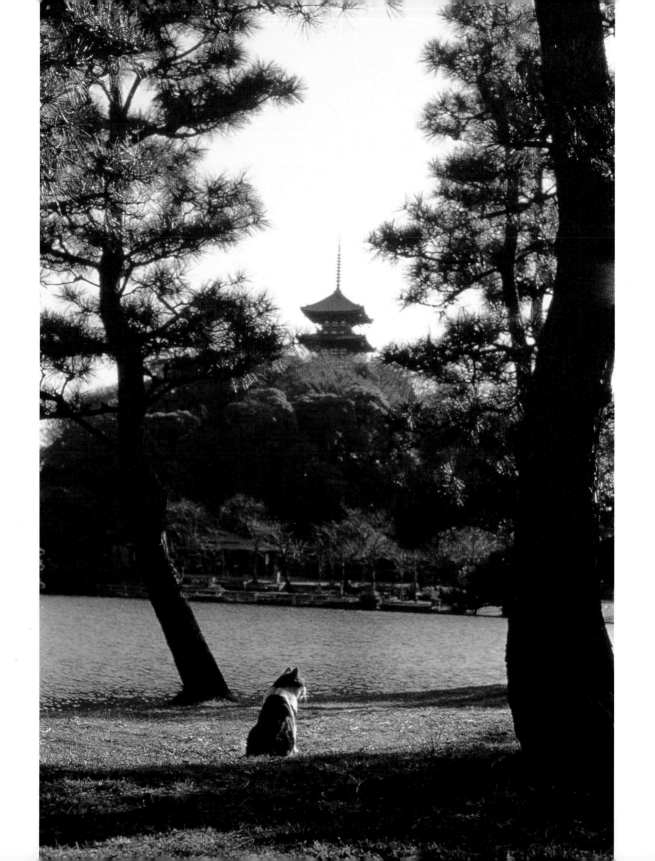

On this road
No one will follow me
In the Autumn evening.

BASHO

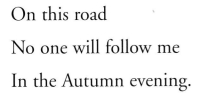

61

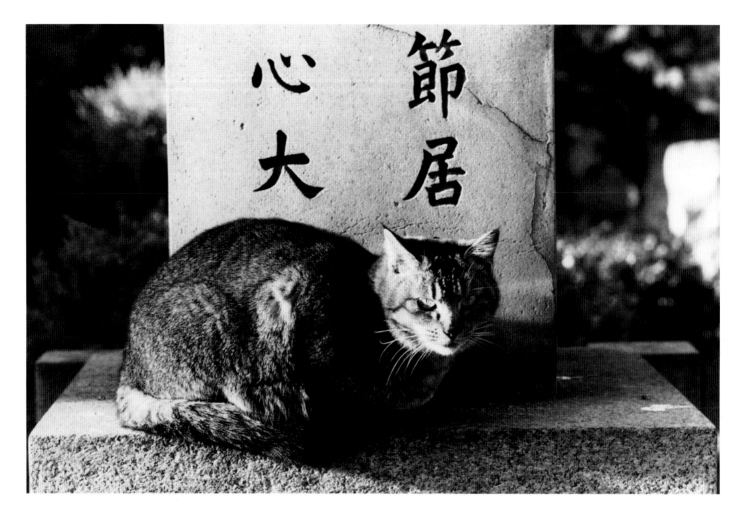

In a cat's eyes round as golden bells,

The mad Spring's flame glows.

<div align="right">JANG-HI LEE, *The Spring is a Cat*</div>

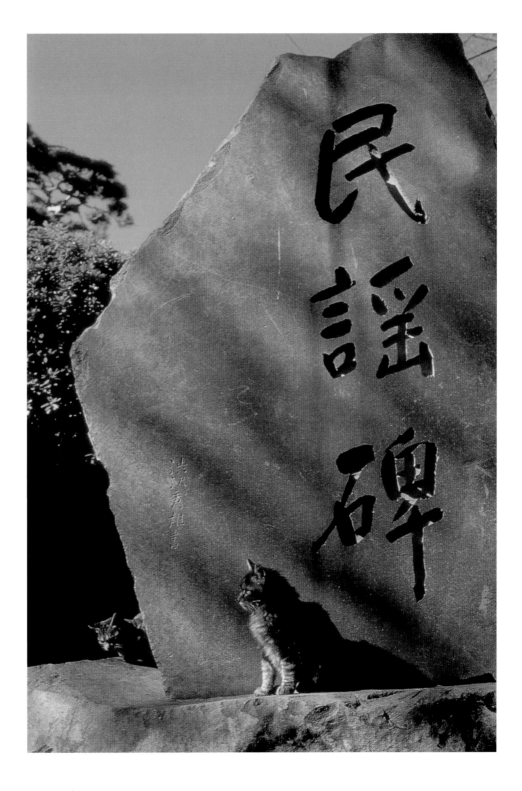

民謡碑

OPPOSITE: Yanaka
Reien Cemetery, Yanaka,
Taito Ward, Tokyo
RIGHT: Gokoku-ji Temple,
Otsuka, Bunkyo Ward, Tokyo

In other days, I was poor enough to suit,

But now I freeze in utter poverty:

I make the deal—it doesn't quite work out,

I take the road—it ends in misery;

I walk in the mud—my feet slip out from under,

I sit in the shrine—my belly gripes at me—

Since I lost the parti-colored cat,

Around the rice-jar, rats wait hungrily.

HAN SHAN, *Cold Mountain Poem No. 158*

Senso-ji Temple,
Asakusa,
Taito Ward, Tokyo

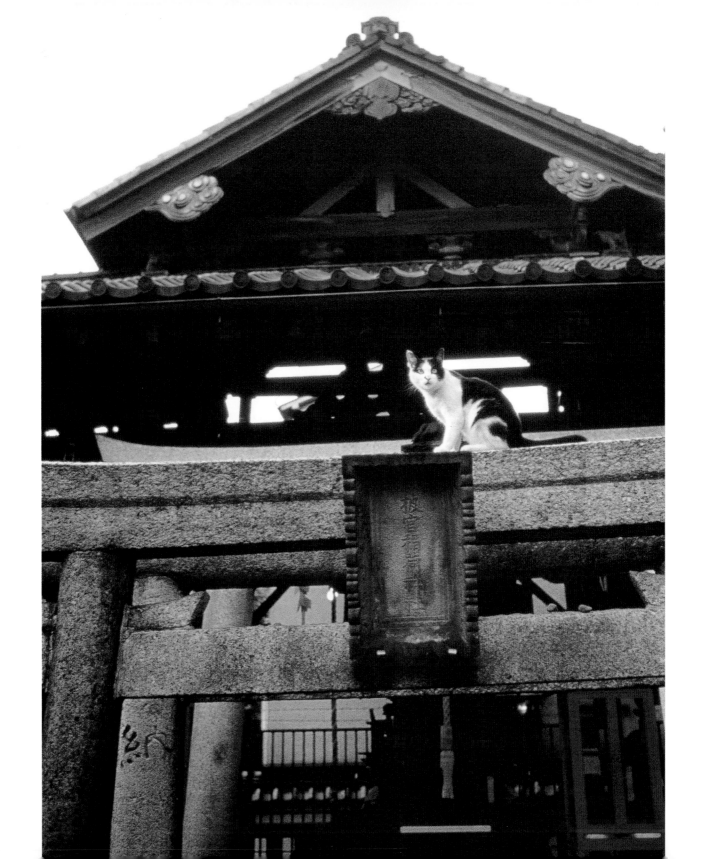

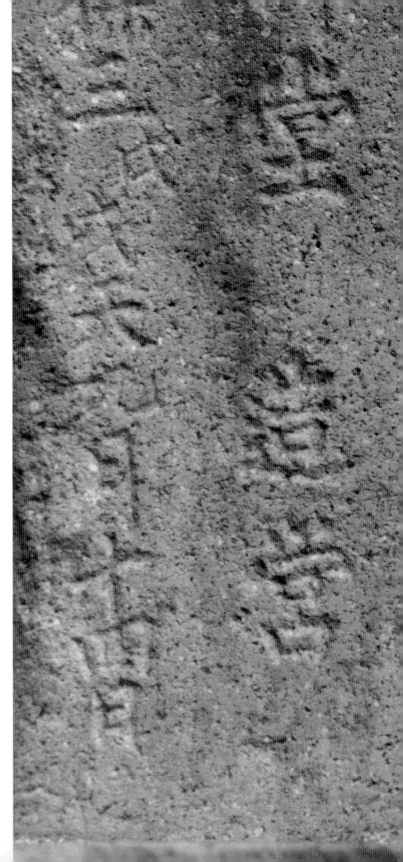

Flourishing his head around

He licks himself smooth and sleek—

The moonlight cat!

Kustatao, *The Cat*

Komyo-ji Temple, Kamakura,
Kanagawa Prefecture

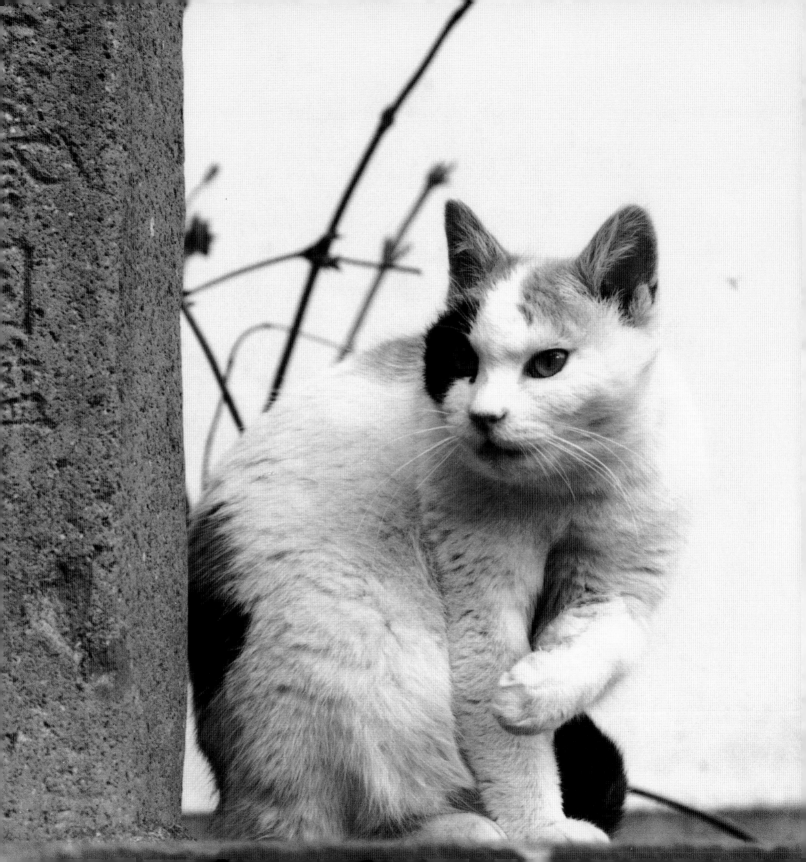

ABOVE AND OPPOSITE:
Komyo-ji Temple, Kamakura,
Kanagawa Prefecture

The cat

sleeps

wakes up

gives one vast yawn

then exists for the

purpose of love.

ISSA, *The Cat*

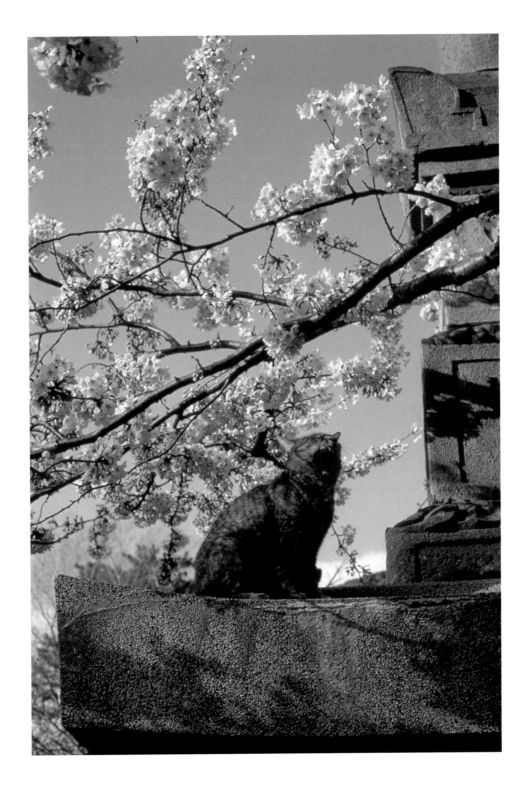

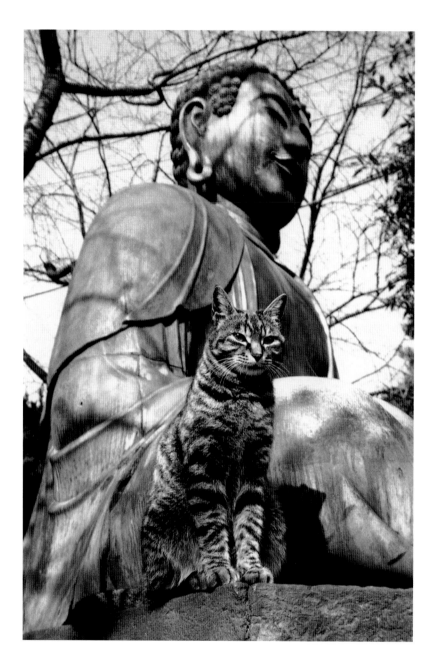

Under this bright moon
I sit like an old buddha
knees spread wide

ISSA

70

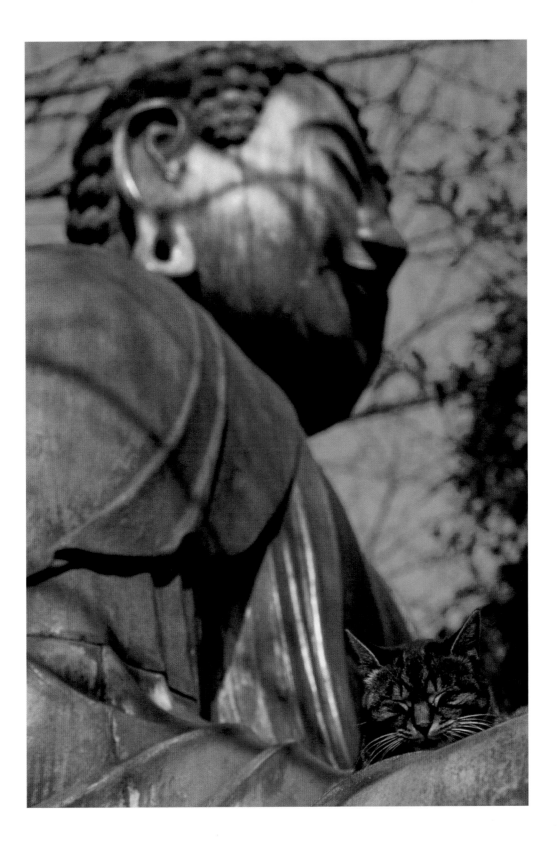

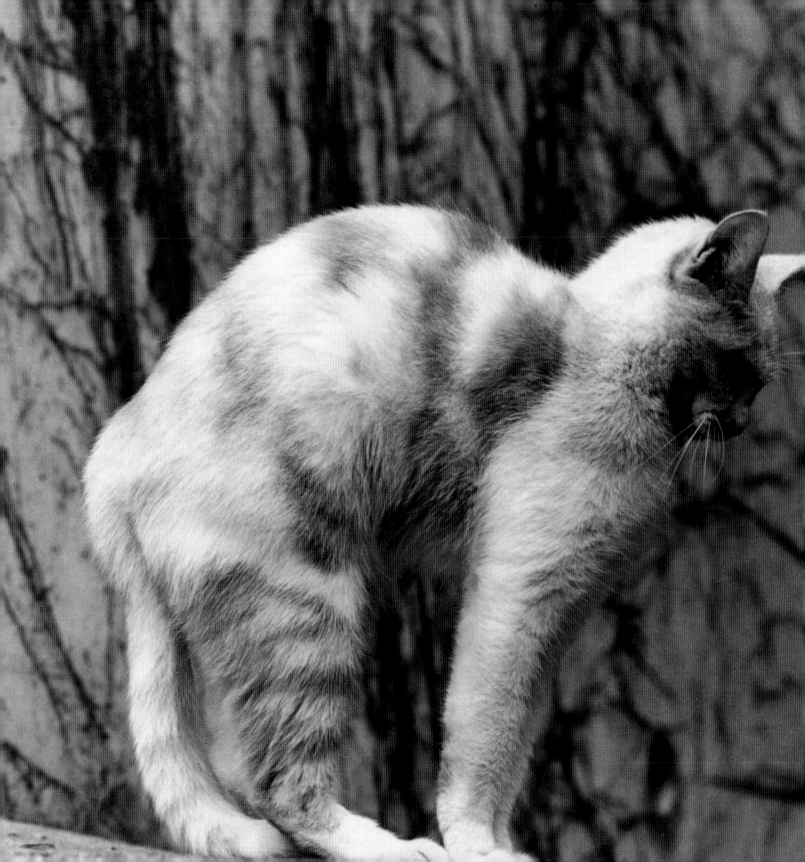

One who rises, rises of himself,
One who falls, falls from himself.
Autumn dew. spring breeze—
Nothing can possibly interfere.

NI-BUTTSU

Ikegami Honmon-ji Temple,
Ota Ward, Tokyo 73

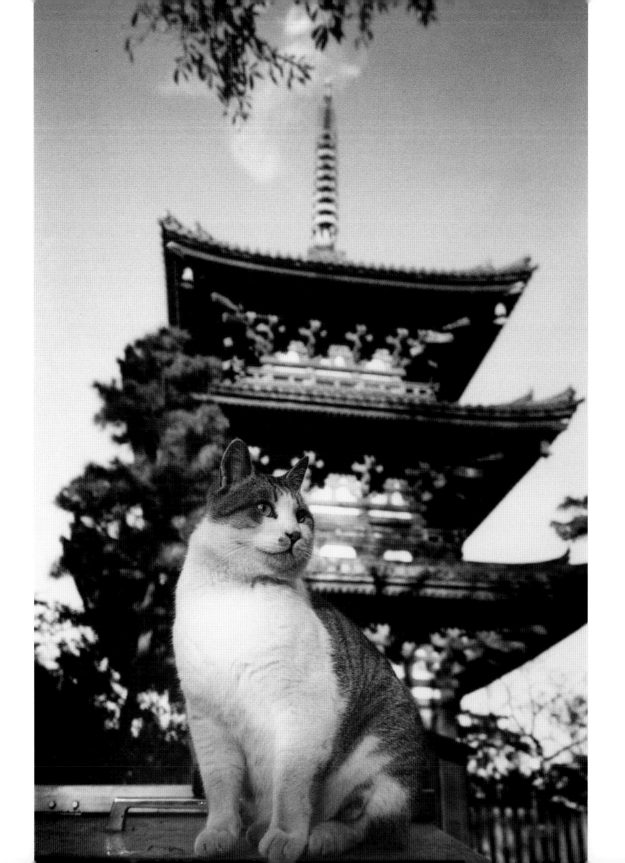

Long ago, the Empress Wu Tse-tien,

Seeking to show that where Buddha's law prevails

All violence and strife must cease,

Ordered that a kitten and a bird

Be trained to eat from the same dish.

The bird, a parrot, was clever and playful;

The cat, in turn, was placid and mild.

And indeed they did take their food together.

Yet when Censor P'eng exhibited them

To the officials at court

To manifest the transforming benevolence

Of Her Majesty's rule,

The cat became nervous, and bit

Her erstwhile comrade to death:

Thus in view of all could be concealed

Neither the violence of the cat

Nor the ambition of the ruler

FELICITY BAST, *The Empress of the Cat,*
AFTER CHANG TSU

Sankeien Garden,
Yokohama,
Kanagawa Prefecture

Look, myriad shapes and forms,

 entranced,

 and bewitched!

A ruby hall glitters gold,

Where fairy maids appear

 and disappear.

THE LU, FROM *Opium*

Enoshima,
Kanagawa Prefecture

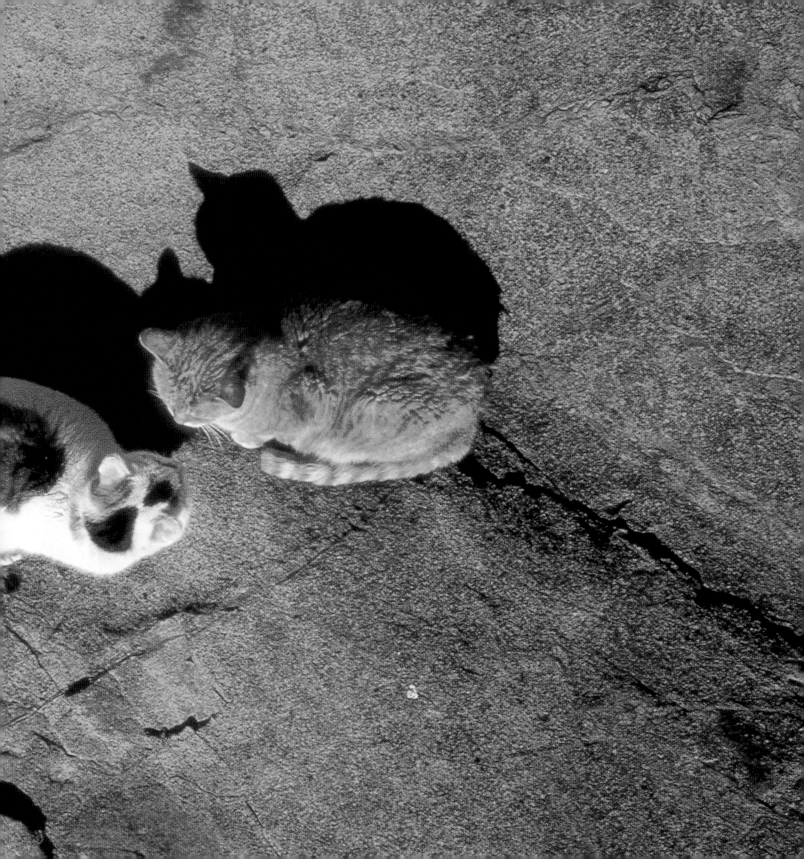

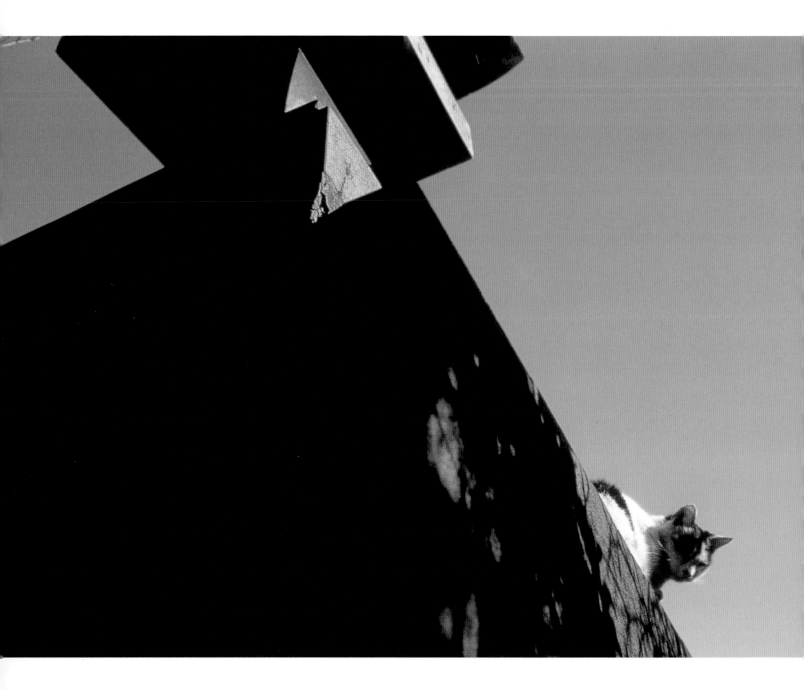

ABOVE: Senso-ji Temple,
Asakusa, Taito Ward, Tokyo
OPPOSITE: Yanaka Reien Cemetery,
Yanaka, Taito Ward, Tokyo

The winter fly
I caught and finally
 freed
the cat quickly ate

 ISSA

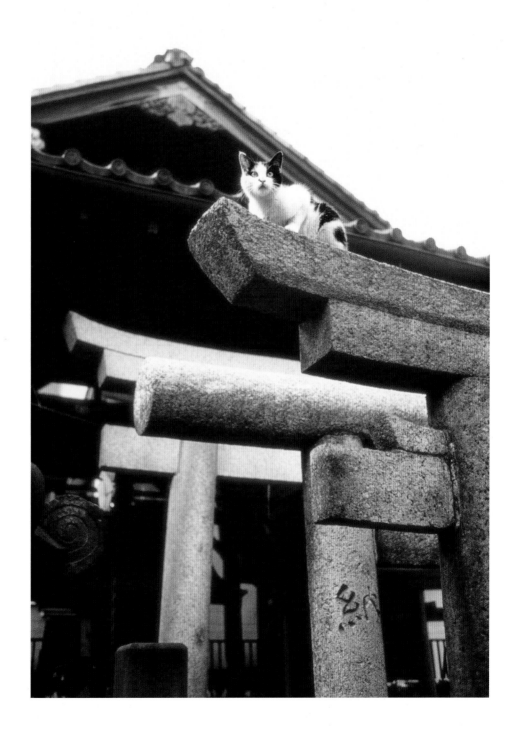

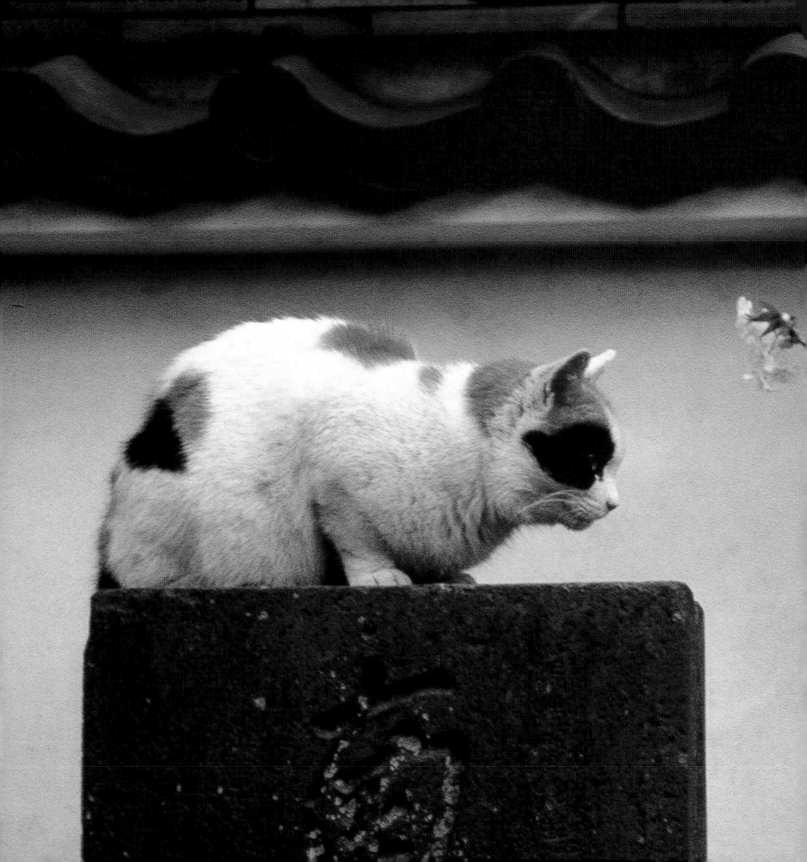

Spring light seems drowsy here

leaning against the breezes

Tu Fu, FROM *Seven For The Flowers*
Near the River

Komyo-ji Temple,
Kamakura, Kanagawa
Prefecture

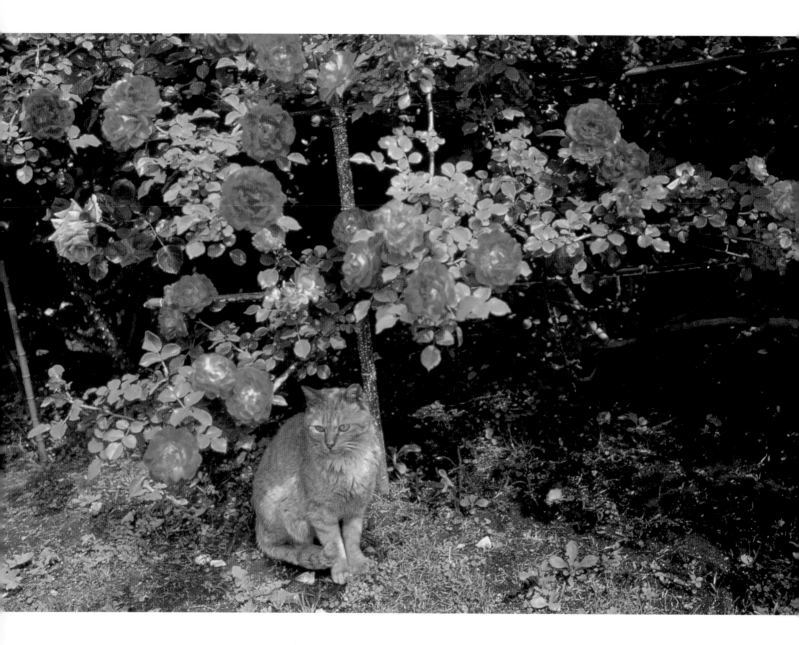

ABOVE: Harbor View Park
(Minato-no-Mieru Oka Koen),
Yokohama, Kanagawa Prefecture
OPPOSITE: Komyo-ji Temple, Kamakura,
Kanagawa Prefecture

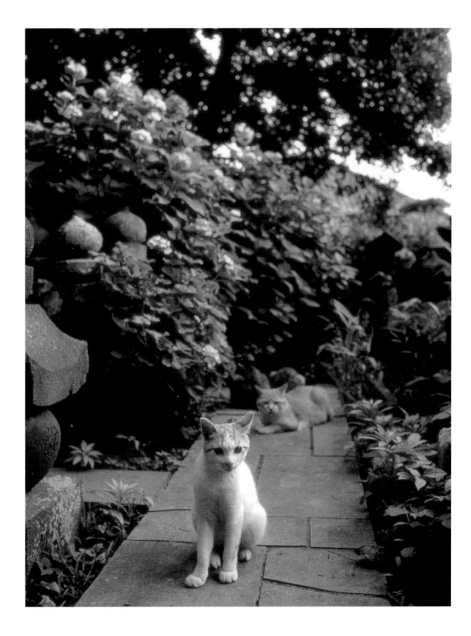

Cats making love in the temple

but people would blame

A man and wife for

 mating in such a place

 KAWAI CHIGETSSU-NI, *Propriety*

83

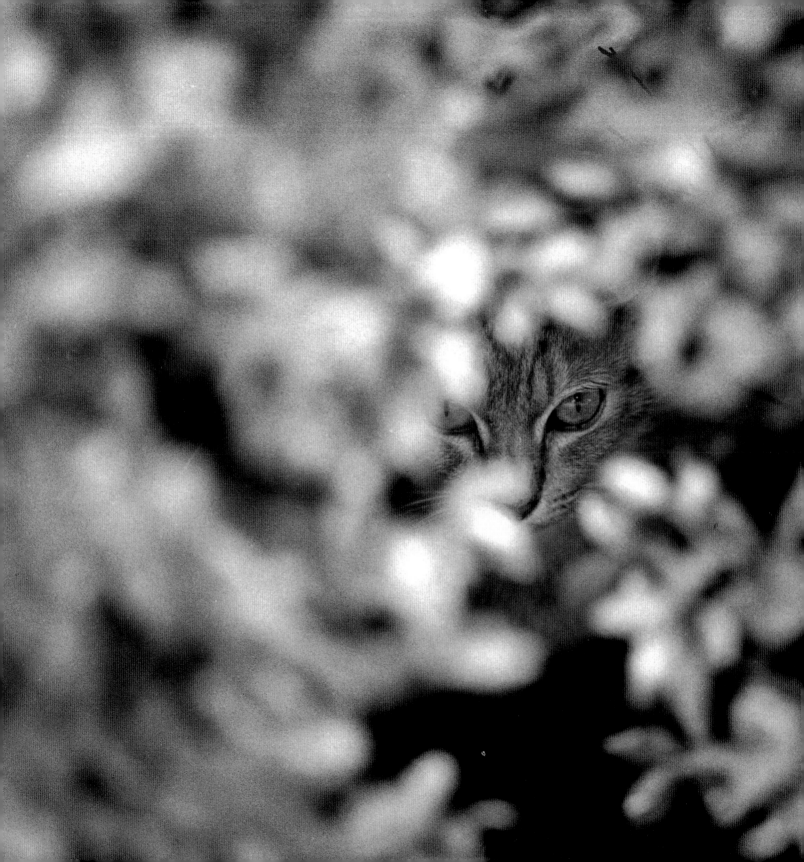

Lost, lonely, they wander in strange
lands.
They find no home where votive
incenses burns—
Forlorn, they prowl and prowl from
night to night.

NGUYEN DU, *Calling All Souls*

Jindai Botanical Gardens,
Chofu, Tokyo

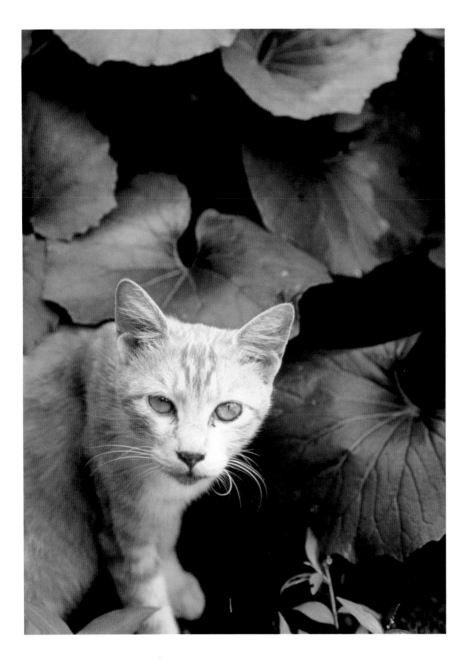

LEFT: Gojo Tenjinsha Shrine, Ueno, Taito Ward, Tokyo
OPPOSITE: Komyo-ji Temple, Kamakura, Kanagawa Prefecture

On a cat's sharp whiskers,
The green Spring's life
 dances.
On a cat's fur soft as pollen,
The mild Spring's fragrance
 lingers.

JANG-HI LEE, *The Spring
is a Cat*

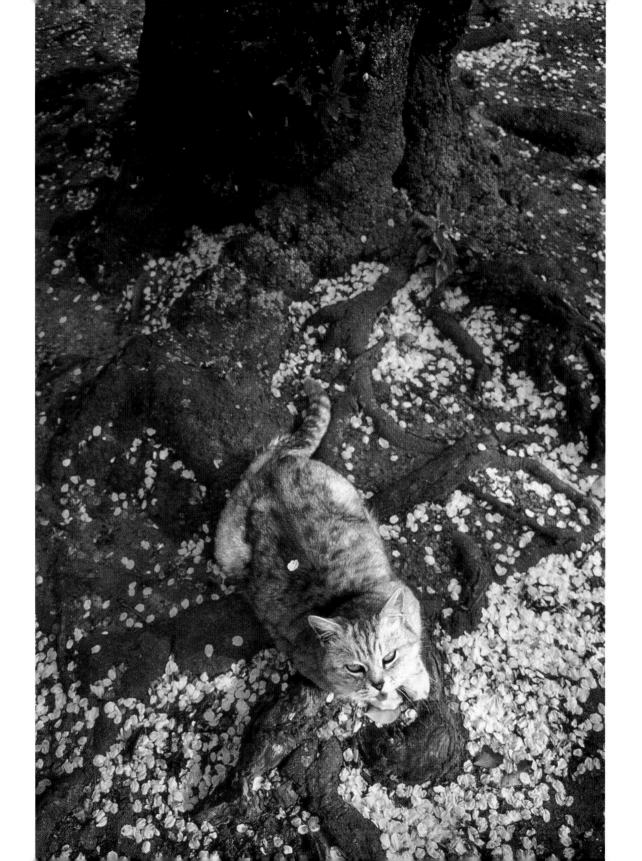

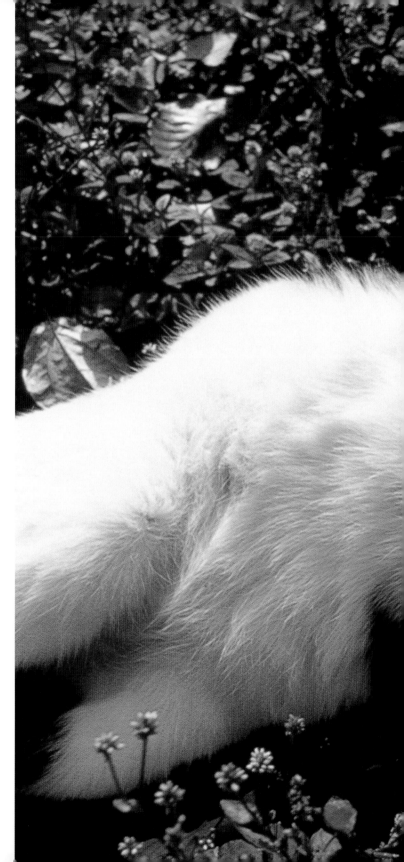

Summer grass

Where warriors dream.

Jochi-ji Temple,
Kita Kamakura,
Kanagawa Prefecture

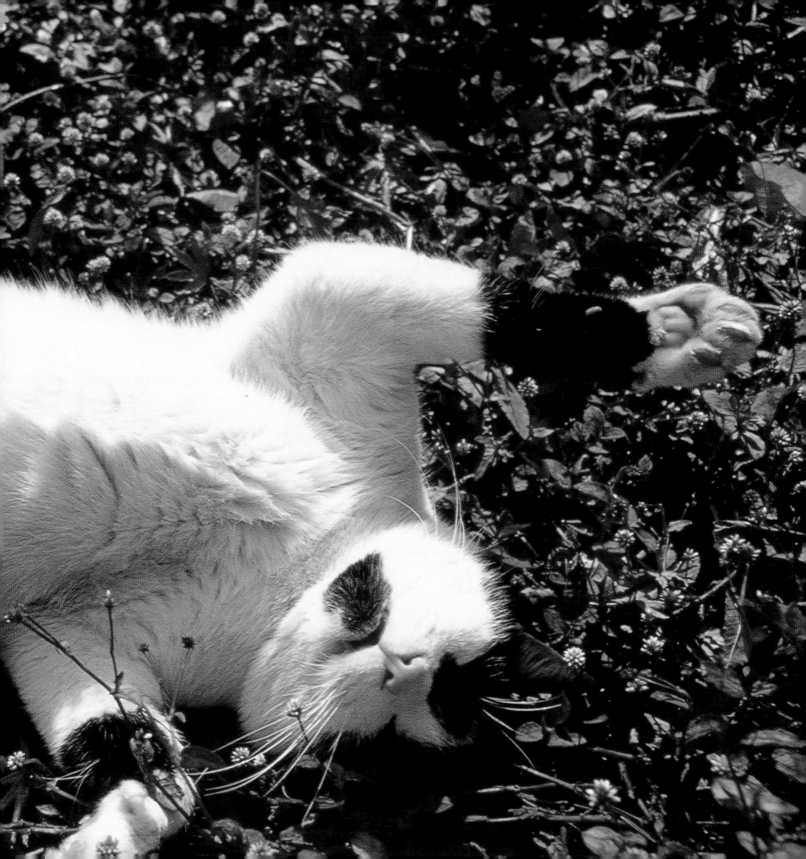

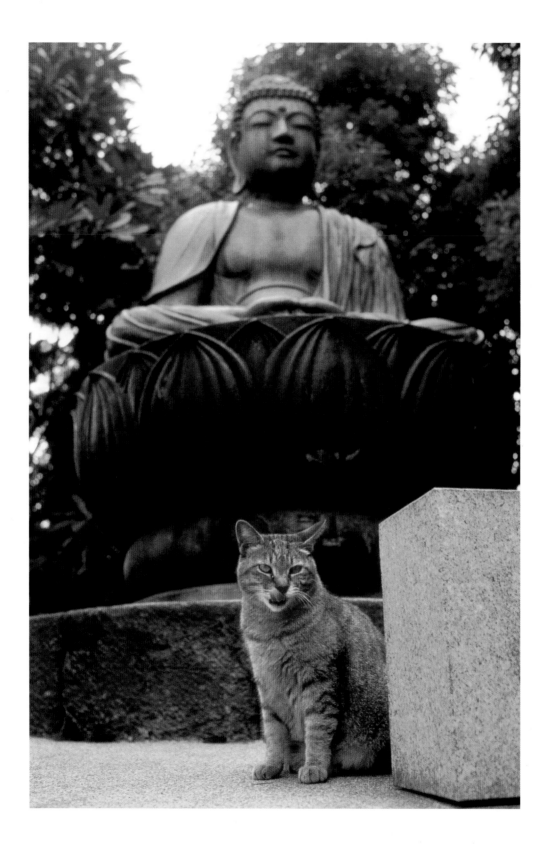

Who said the sea's concave,

Mountains convex?

Why, I swallow them whole—

The boneless sky!

HEISHIN

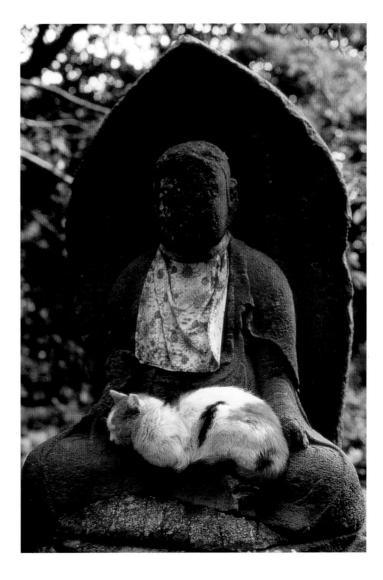

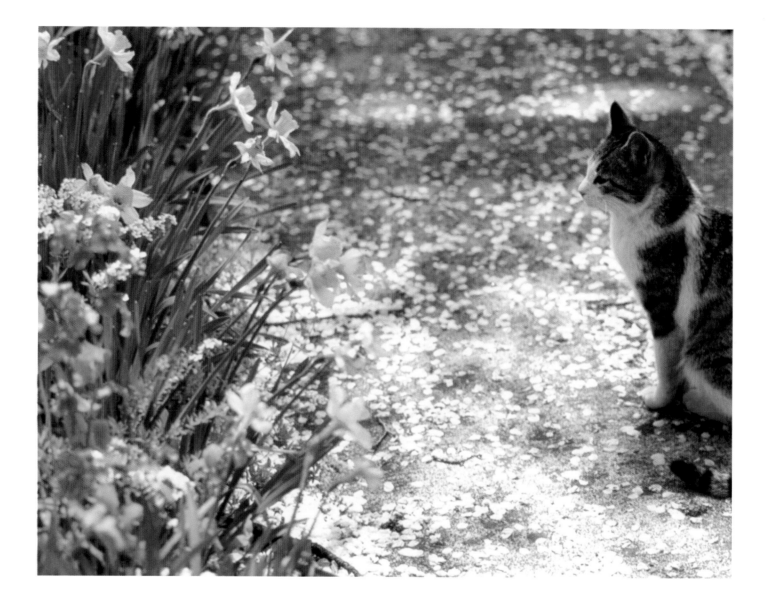

On a cat's gently closed lips,

The soft Spring's drowsiness lies.

JANG-HI LEE, *The Spring is a Cat*

OPPOSITE: Iwase Farm, Kagami-ishimachi,
Fukushima Prefecture (where Yoshiyuki Yaginuma
was born and raised)
BELOW: Nishiarai Daishi, Adachi Ward, Tokyo

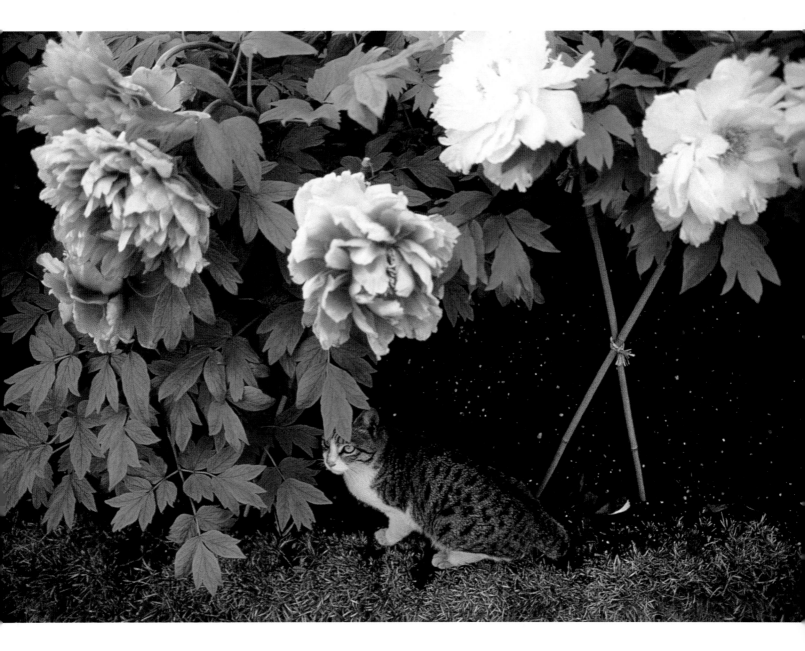

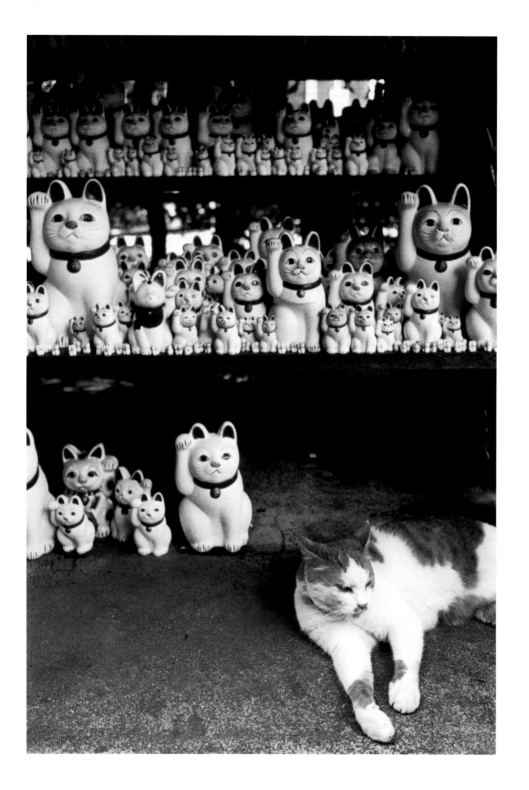

Nishiarai Daishi,
Adachi Ward, Tokyo

Front cover: Gokoku-ji Temple, Otsuka, Bunkyo Ward, Tokyo
Back cover: Yanaka Reien Cemetery, Yanaka, Tito Ward, Tokyo
Frontispiece: Ikegami Honmon-ji Temple, Ota Ward, Tokyo

Editor: Susan Costello
Production Editor: Ashley Benning
Designer: Patricia Fabricant
Production Manager: Louise Kurtz

Photographs and woodcuts © 2000 Yoshiyuki Yaginuma (Mega Press).
Text © 2000 Abbeville Press.

We're grateful to the following sources for their permission to reproduce poems. Every effort has been made to reach
copyright owners. The publisher will gladly correct omissions or mistakes in future printings.
Pages, 13, 23, 37, 41, 48, 70, 79: From *The Sound of Water*, translated by Sam Hamill. ©1995 by Sam Hamill.
Reprinted by arrangement with Shambhala Publications, Inc. Boston, www.shambhala.com.
Page 15: From *The Dhammapada: The Sayings of the Buddha* by Thomas Byrom, trans. © 1976 Thomas Byrom.
Reprinted by permission of Alfred A. Knopf, a Division of Random House Inc.
Pages 16, 28, 57, 88: From *One Hundred Poems from the Japanese* by Kenneth Rexroth. © 1955 by New Directions
Publishing Corp. Reprinted by permission of New Directions Publishing Corp.
Pages 19, 30, 53, 59, 76, 85: From *An Anthology of Vietnamese Poems* (1996) by Huynh Sanh Thong. Reprinted by
permission of Yale University Press.
Pages 20, 51, 56: From *The Columbia Book of Chinese Poetry*, trans. Bruno Watson. ©1984 Columbia University Press.
Page 25: Reprinted from *Call Me By My True Names: The Collected Poems of Thich Nhat Hanh* (1993) by Thich
Nhat Hanh with permission of Parallax Press, Berkeley, California.
Pages 27, 33, 34, 55, 83: From *Women Poets of Japan* by Kenneth Rexroth. © 1977 by Kenneth Rexroth and Ikuko
Atsumi. Reprinted by permission of New Directons Publishing Corp.
Pages 39, 46, 73, 91: From *The Zen Poems of China and Japan: The Crane's Bill* by Lucien Stryk and Takeshi
Ikemoto. © by Lucien Stryk, Takashi Ikemoto, and Taigan Takayama.
Pages 43, 81: From *Five T'ang Poets: Wang Wei, Li Po, Tu Fu, Li Ho, Li Shang-yin*, translated and introduced by
David Young, FIELD Translation Series 15, Oberlin College Press © 1990. Reprinted by permission of Oberlin
College Press.
Pages 44, 66: From *In the Eyes of the Cat: Japanese Poetry for All Seasons*, selected and illustrated by Demi, translated
by Tze-si Huang. © 1992 by Demi. Reprinted by permission of Henry Holt and Company, LLC.
Page 61: From *One Hundred More Poems from the Japanese* by Kenneth Rexroth. © 1976 by Kenneth Rexroth.
Reprinted by permission of New Directions Publishing Corp.
Page 64: Translated by E. Bruce Brooks. © 1995 by E. Bruce Brooks. Reprinted by permission of E. Bruce Brooks.

First edition
10 9 8 7 6 5 4 3 2 1
Library of Congress Cataloging-in-Publication Data
Yaginuma, Yoshiyuki.
Zen cats / photographs by Yoshiyuki Yaginuma ; text by Jana Martin.– 1st ed.
p. cm.
ISBN 0-7892-0702-8
1. Cats–Japan–Pictorial works. 2. Photography of cats. 3. Zen Buddhism. I. Martin, Jana. II. Title.

SF446.Y24 2001
636.8'0952'022–dc21 00-53599

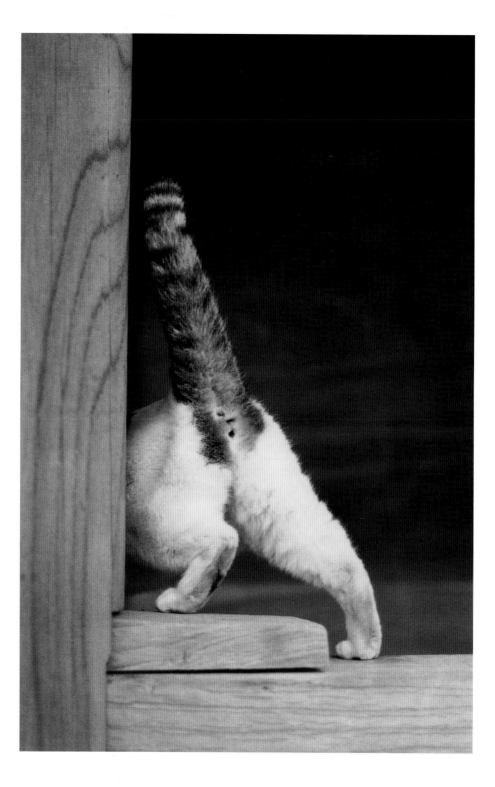

Komyo-ji
Temple,
Kamakura,
Kanagawa
Prefecture